FLEXIBLE

フレキシブル よー清水作品集

Yo Shimizu

Concept artist, designer, illustrator. Started working freelance as a concept artist mainly for video games and anime as a student. Has been involved in the making of "FINAL FANTASY VII REMAKE" (SQUARE ENIX), "GUNDAM FACTORY YOKOHAMA" (SOTSU / SUNRISE), "Hypnosis Mic" (KING RECORD), and "KABANERI OF THE IRON FORTRESS – THE BATTLE OF UNATO" (WIT STUDIO), among others. In recent years, his field of activity expanded across a variety of media, ranging from illustrations for goods, advertisements, manga and technical guidebooks, to co-development of creative software.

FLEXIBLE: The Art of Yo Shimizu

Author: Yo Shimizu
Designer: Shunsuke Sugiyama
Translator: Andreas Stuhlmann, STAR Japan Co., Ltd.
Editor: Keiko Kinefuchi (PIE International)

PIE International Inc.
2-32-4 Minami-Otsuka, Toshima-ku, Tokyo 170-0005 JAPAN
international@pie.co.jp
www.pie.co.jp/english

ISBN978-4-7562-5539-6 (Outside Japan)
Printed in Japan

はじめに

本書のタイトル「FLEXIBLE」は「柔軟な」という意味です。
これは「私の仕事のスタイルや描き方を一言で表すと何だろう？」と考えてつけたものです。

私は誰かのために絵を描くことが好きで、それを仕事にしています。
さまざまな「誰か」の欲しいものを作るための、私なりのキーワードが「FLEXIBLE」です。

例えば、私が最も得意とする絵は世界観を描いた背景作品ですが、要望があればキャラクター、
メカ、モンスター、時には映像作品のエフェクトのデザインなど、あらゆるものを描きます。
また、画風というものをあえて決めていません。もちろん慣れた描き方やクセなどはありますが、
依頼の内容や表現したいことによって絵柄も描き方も柔軟に変化させるようにしています。

見方によっては「FLEXIBLE」は節操がないと感じるかもしれませんが、
私が絵を描く上で大切にしていることの一つです。

本書を通して、さまざまな作品を楽しんでいただければ嬉しいです。

Foreword

"FLEXIBLE," the title of this book, is what came to my mind when thinking about how to describe both my working and drawing styles in a single word.

I generally like to draw pictures for other people, and that's what I now do for a living. "Flexible" is exactly what I need to be in order to give all kinds of "other people" what they ask for.

Take the background pictures, for example, which I am somewhat specializing in. They project certain world concepts, into which I insert whatever the client requests: characters, mechanisms, monsters, and sometimes design effects in video works.
I have chosen not to adhere to one particular depiction style. There are of course habits and certain ways of drawing things that I've gotten used to, but I always try to be flexible regarding designs and styles, depending on the assignment and what I want to do with it.

Some may interpret "being flexible" as "being inconstant," but for myself, this is one of the qualities that I value most when drawing pictures.

I hope you enjoy this book as an introduction to my broad-ranged work.

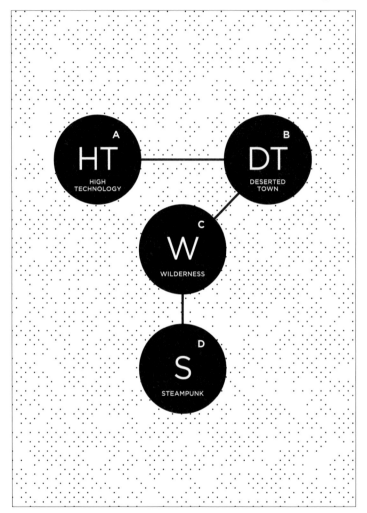

TECHNOLOGY AND NATURE

テクノロジーと自然。この二つは私が最も好むモチーフの一つです。
ワクワクするテクノロジーと畏怖を抱く壮大な自然の対比を
感じてもらえれば嬉しいです。

Technology and nature. The combination of these two is one of
my favorite subjects. It is my desire to make people feel
the contrast between the excitement of technology
and the awe-inspiring vastness of nature.

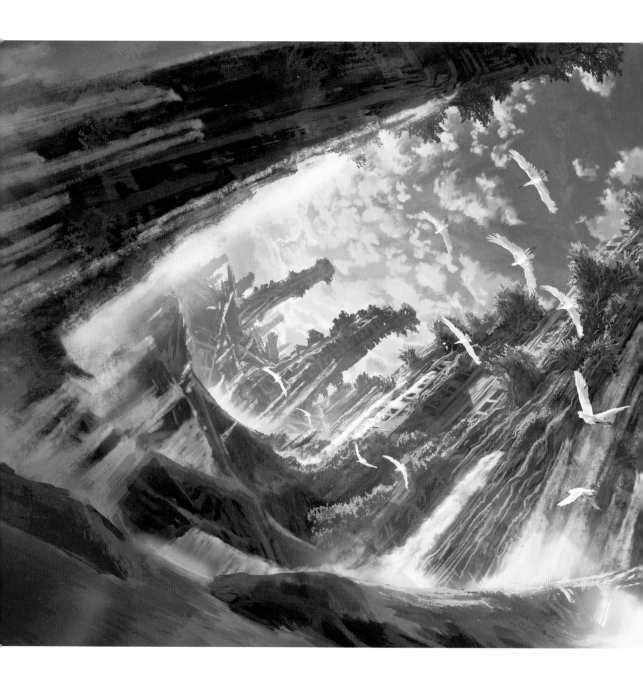

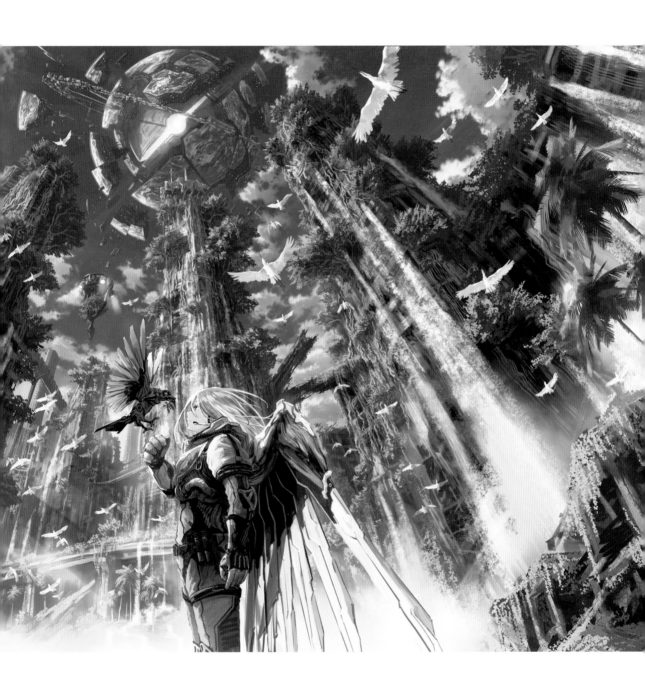

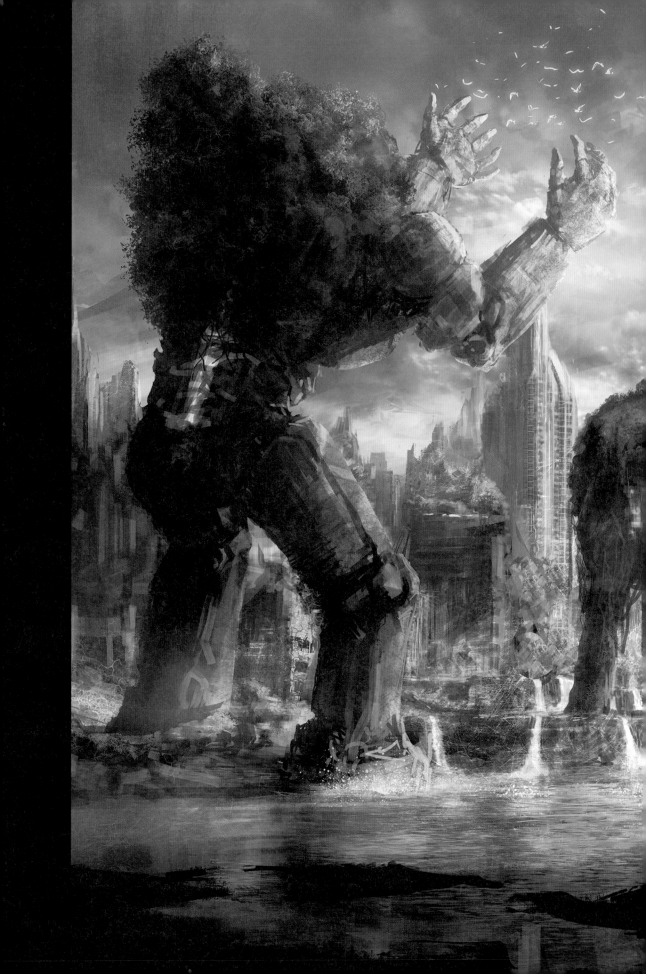

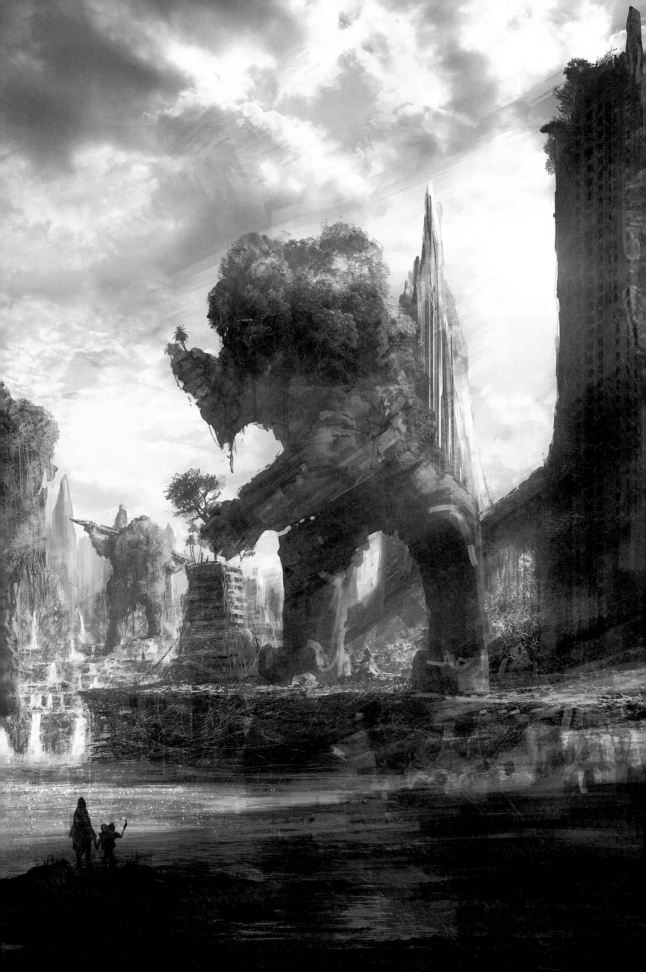

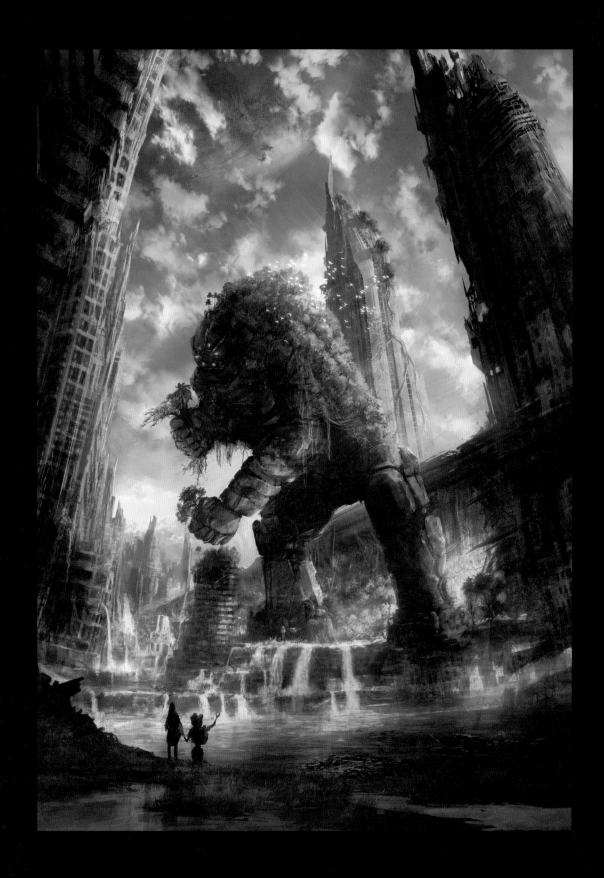

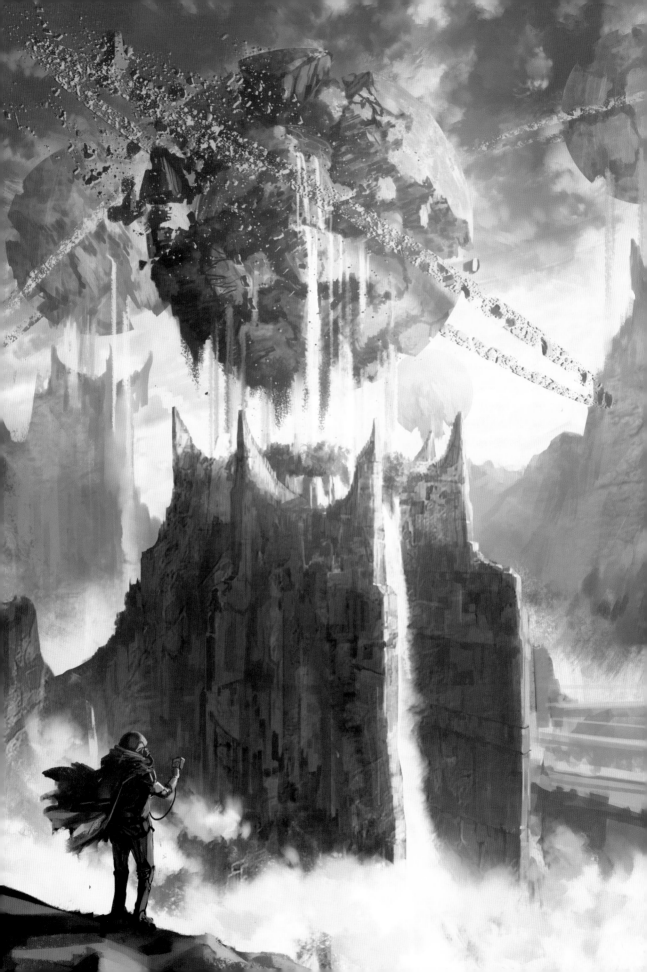

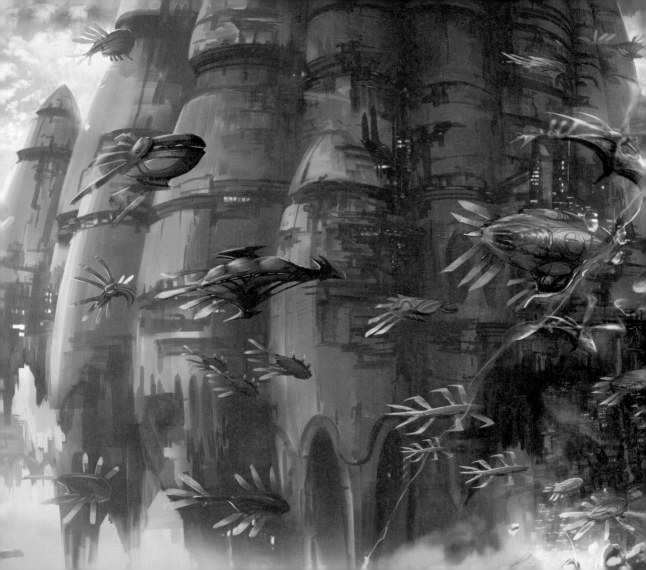

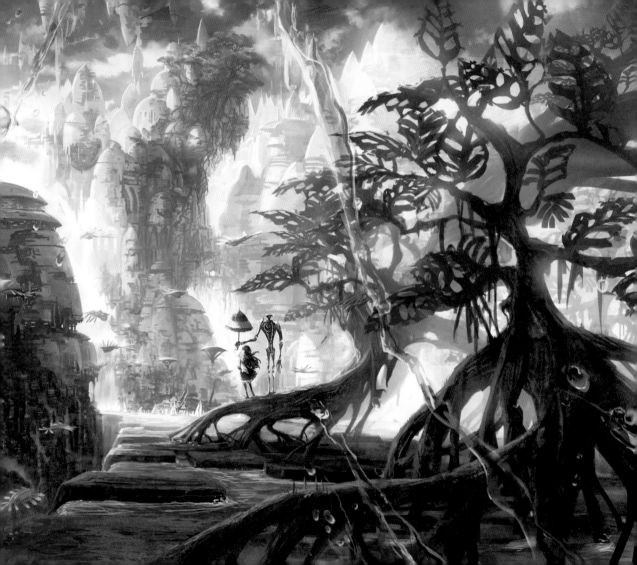

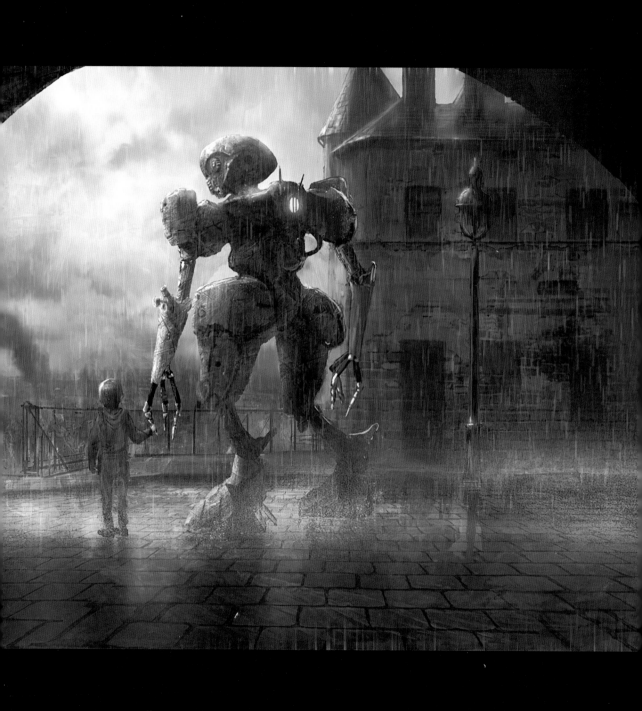

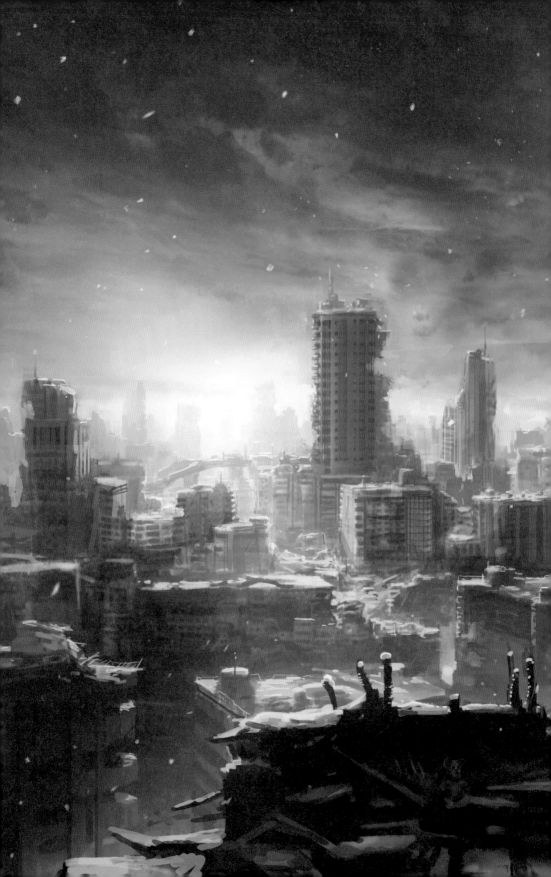

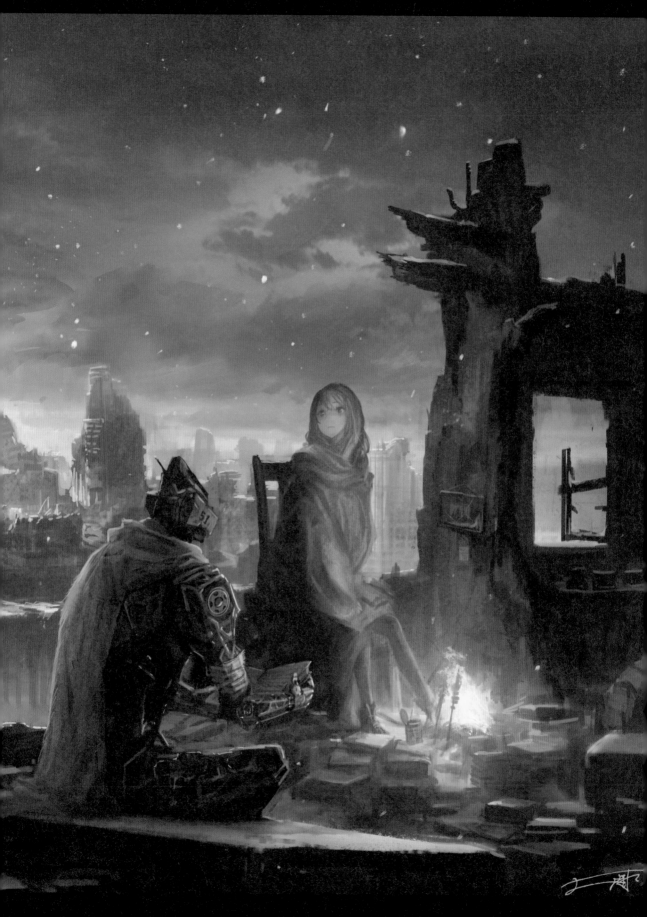

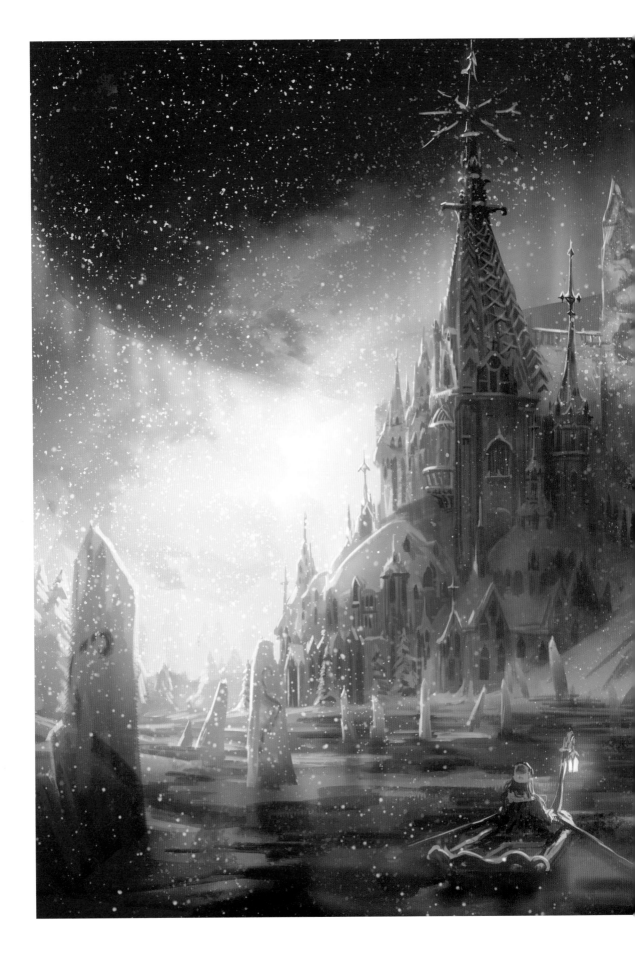

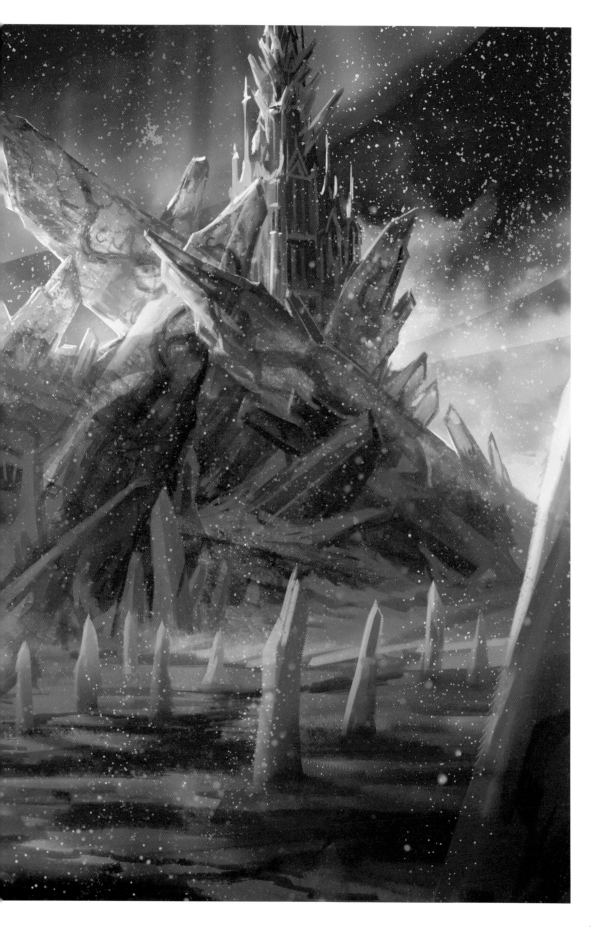

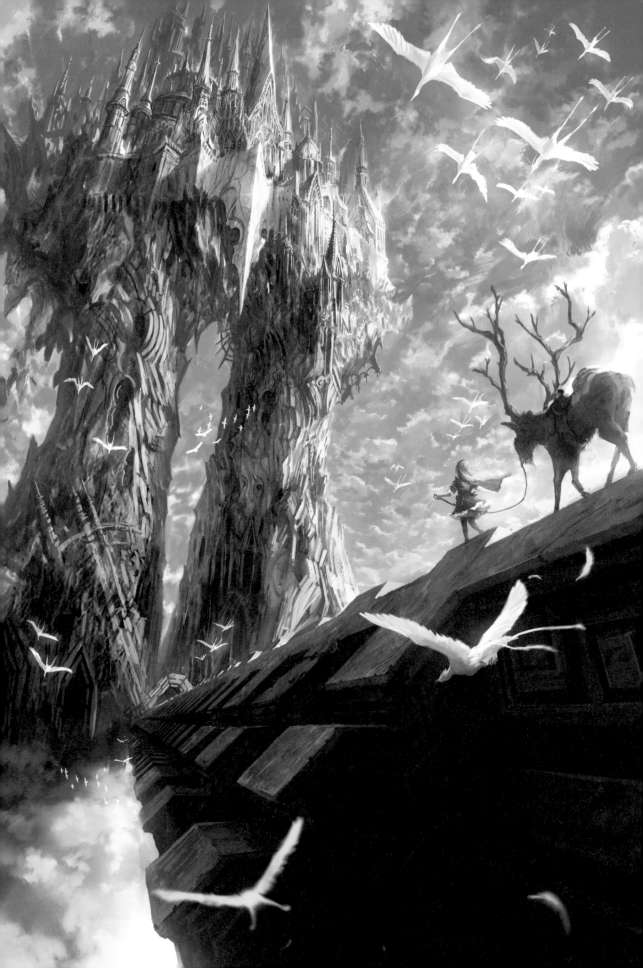

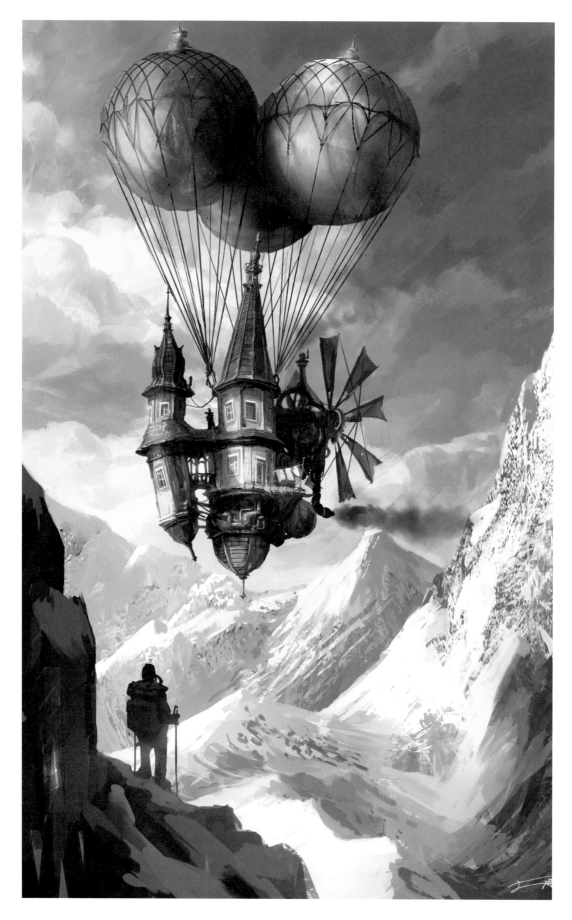

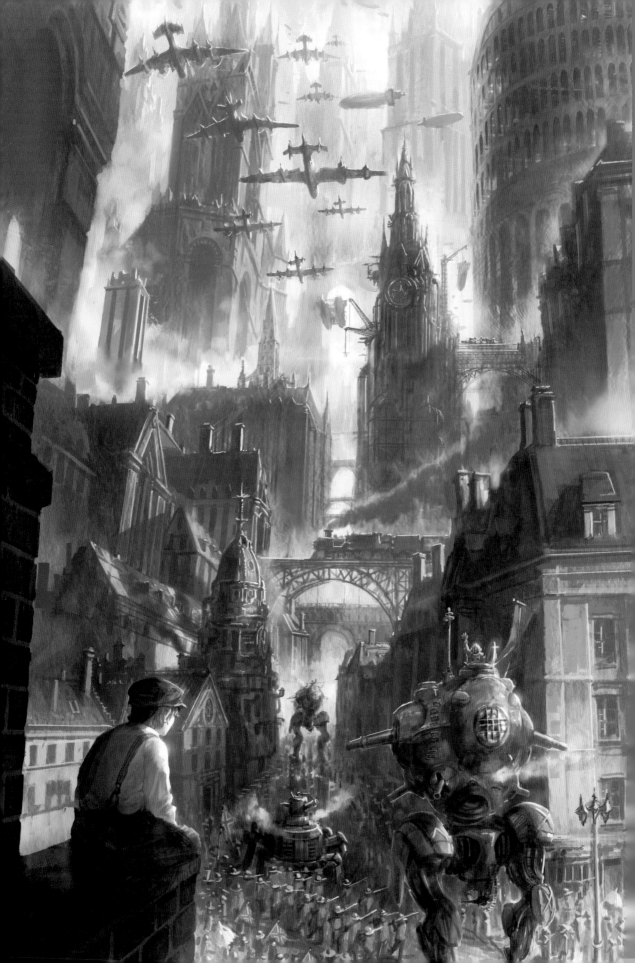

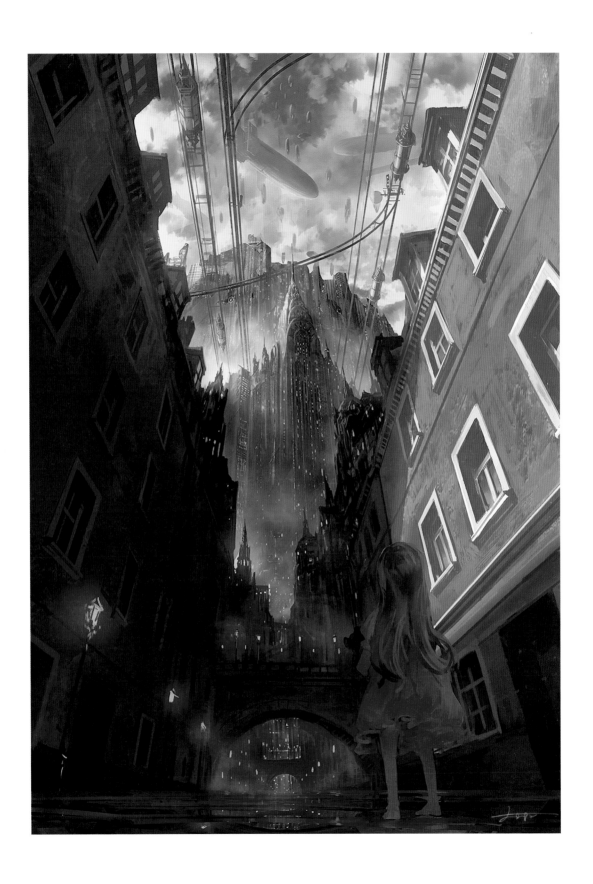

CHARACTERS AND NARRATIVES

キャラクターとストーリー。私は世界観を描くことが多いですが、絵の中で物語が展開されているような作品を描くこともあります。一つ一つの作品に込められた物語を紐解いていただけると嬉しいです。

Characters and narratives. My work often revolves around settings representing conceptual worlds, but I also draw pictures in which some kind of narrative seems to unfold. I like people to look at my works and read the individual stories that each of them tells.

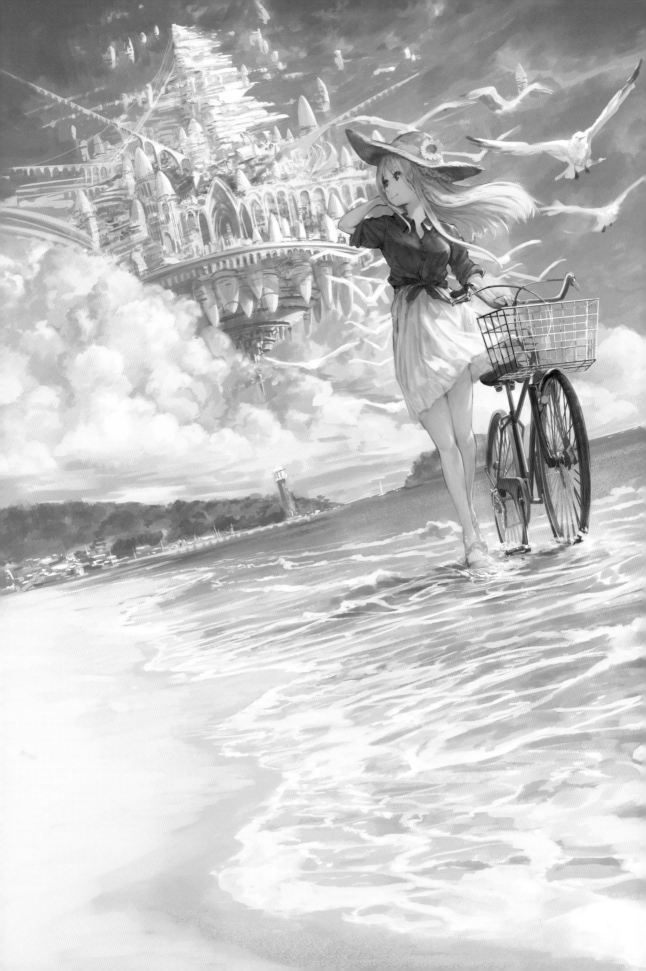

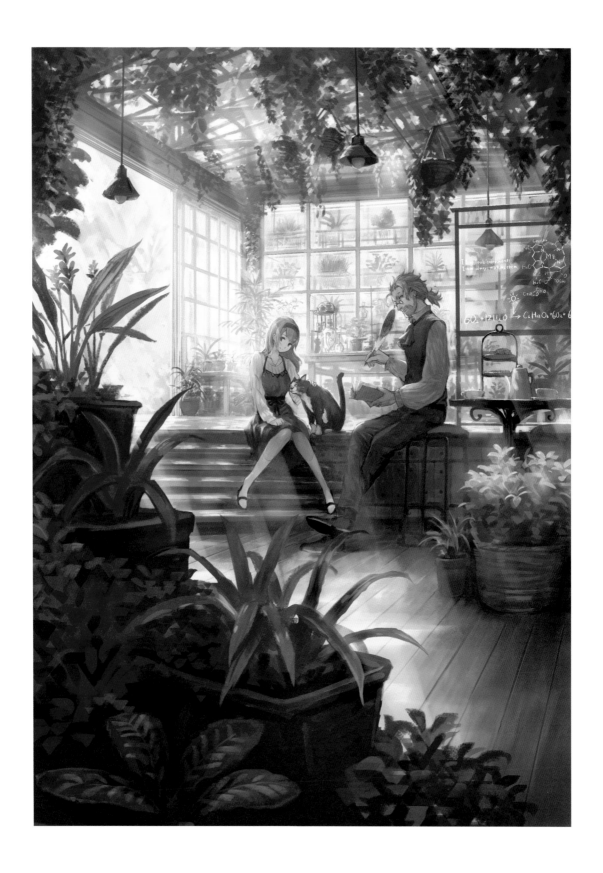

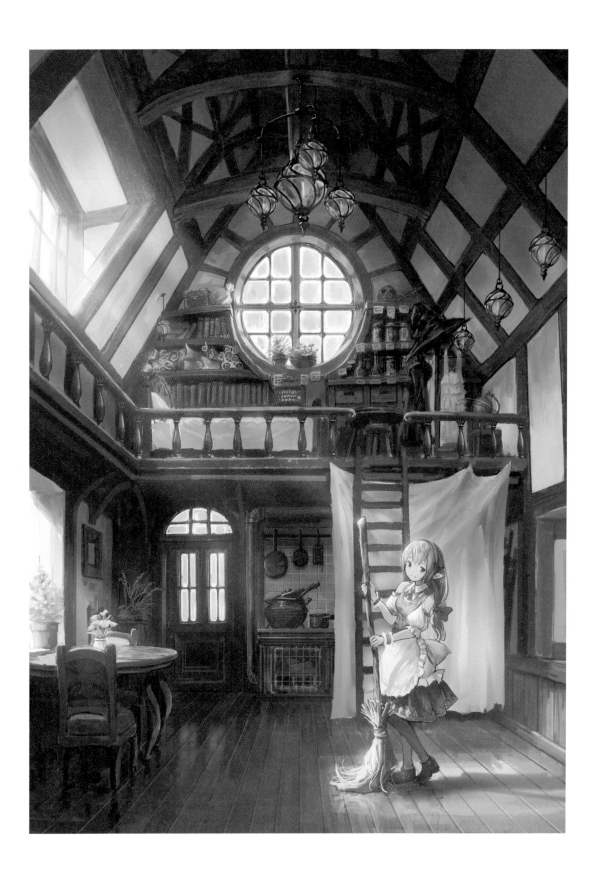

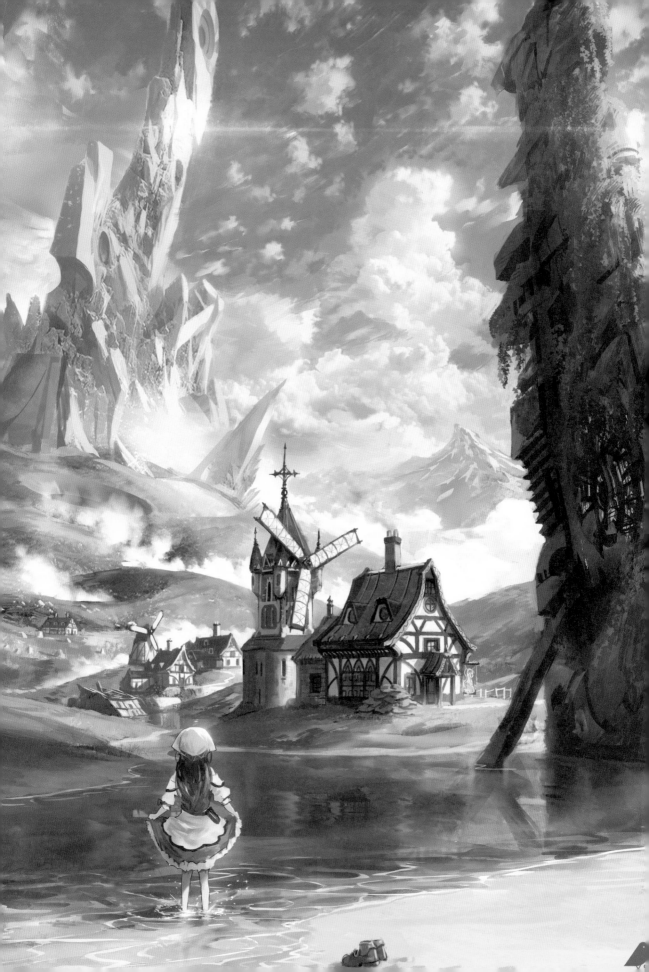

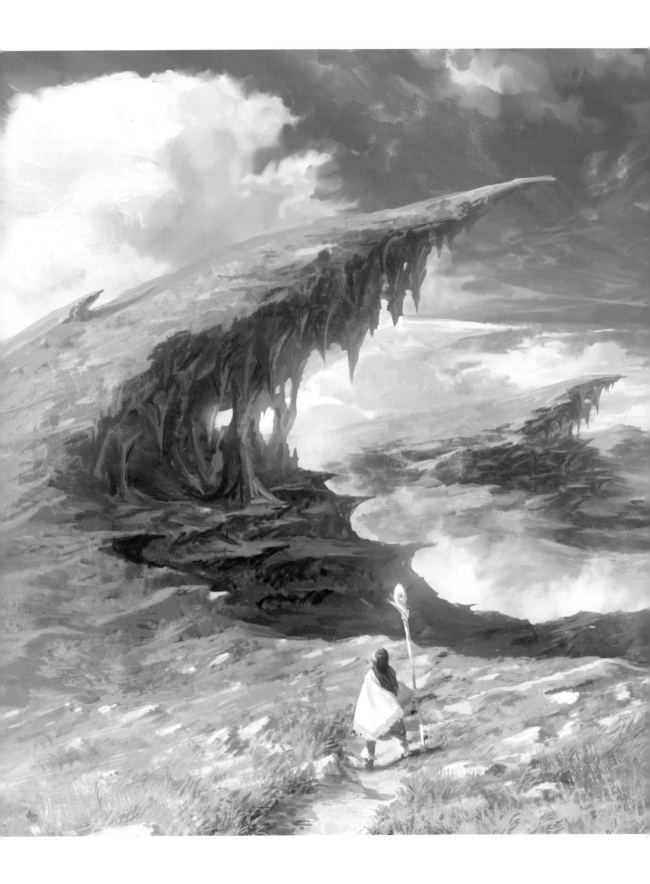

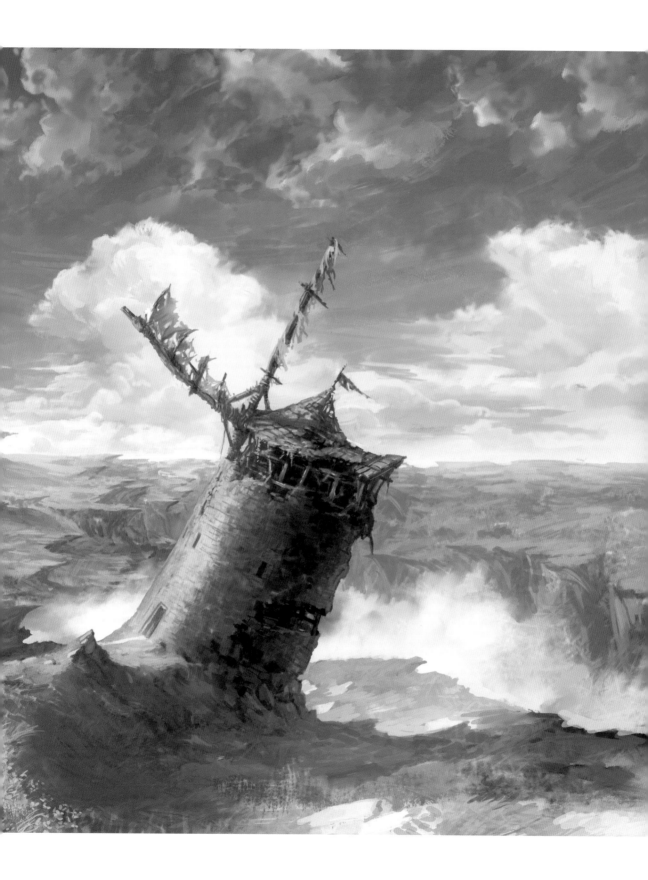

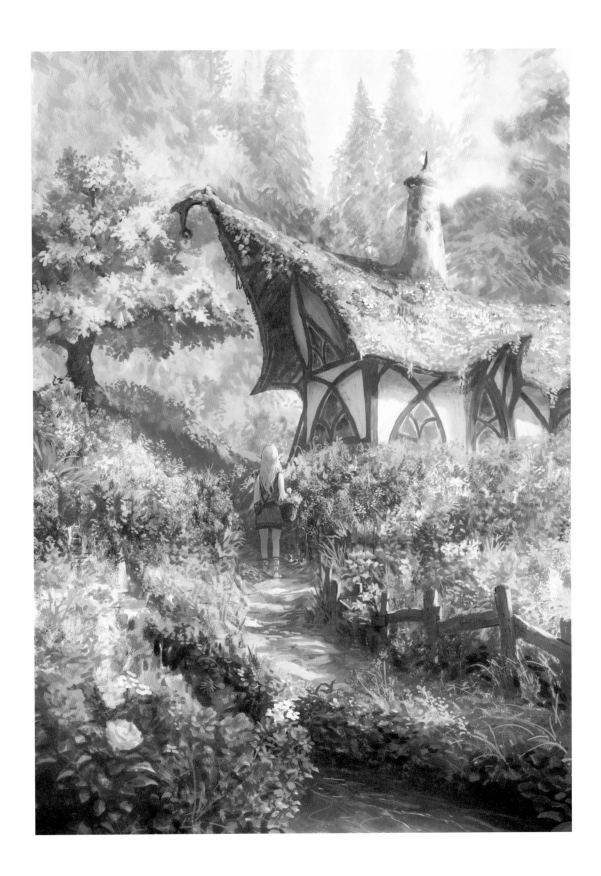

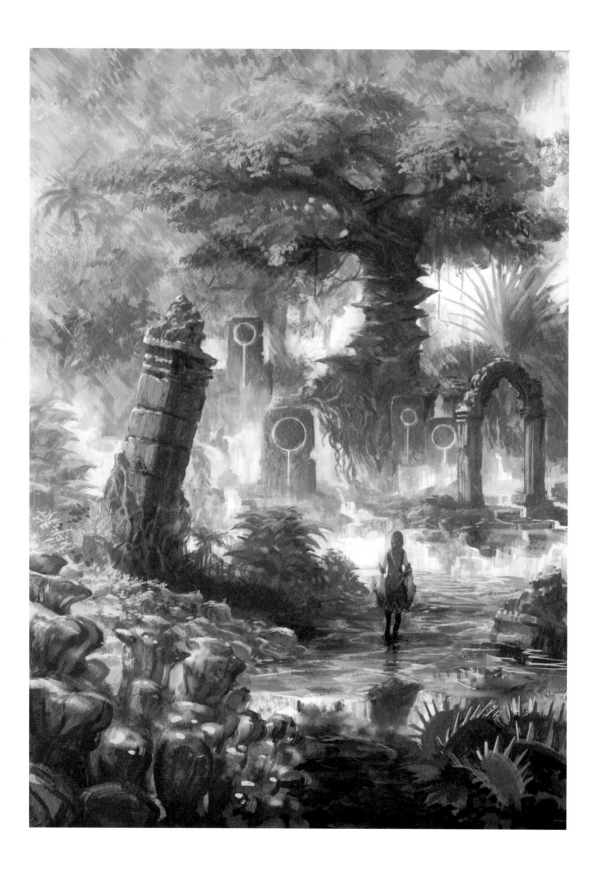

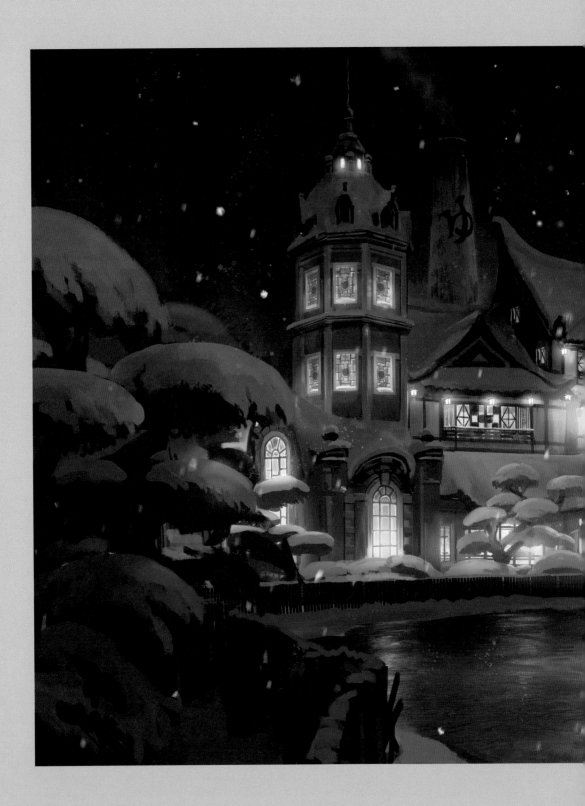

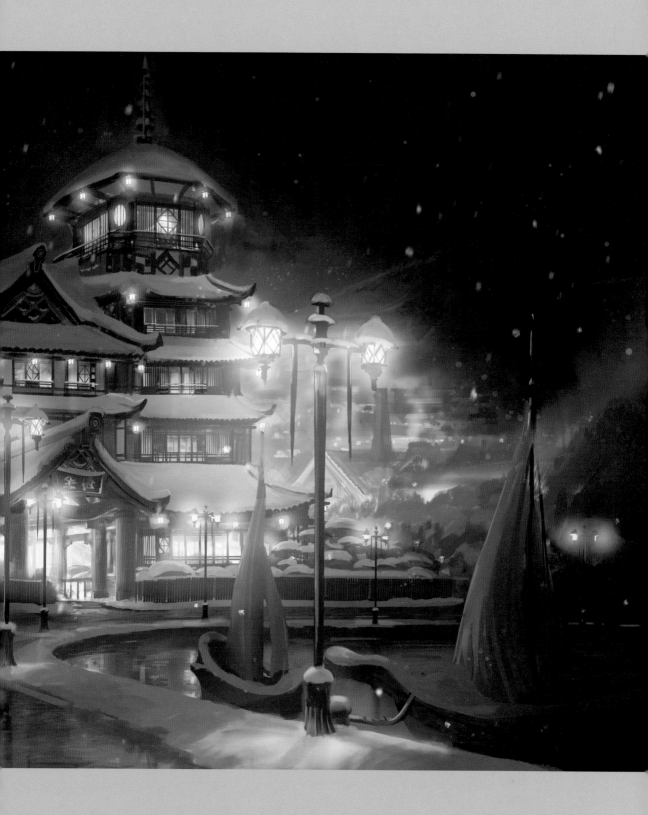

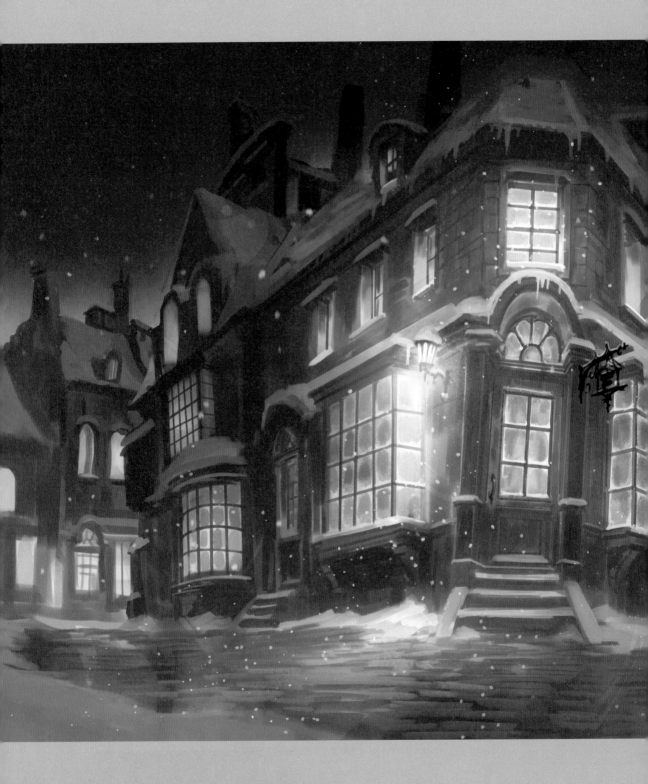

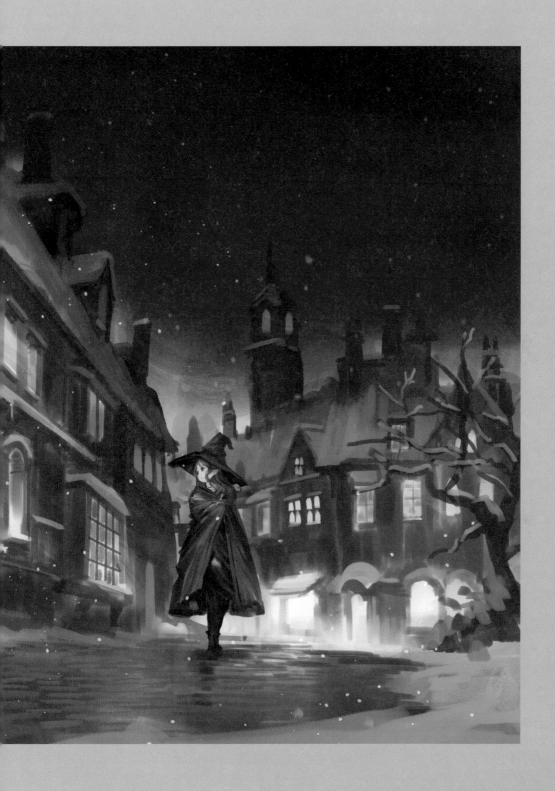

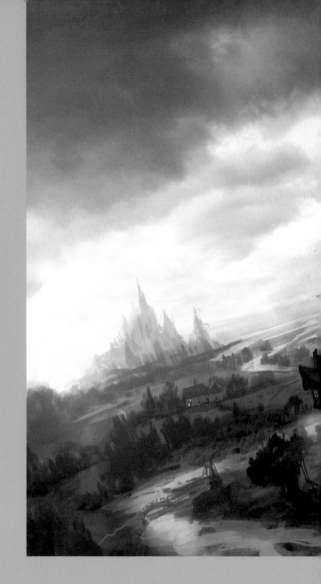

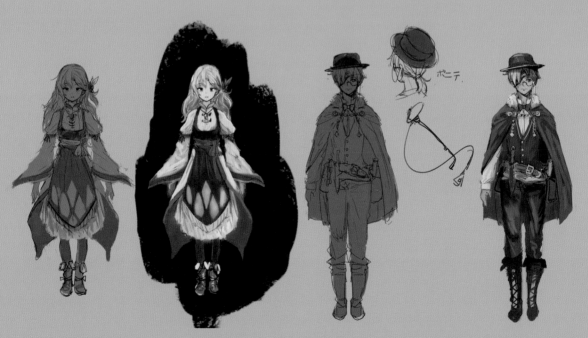

ポニテ.

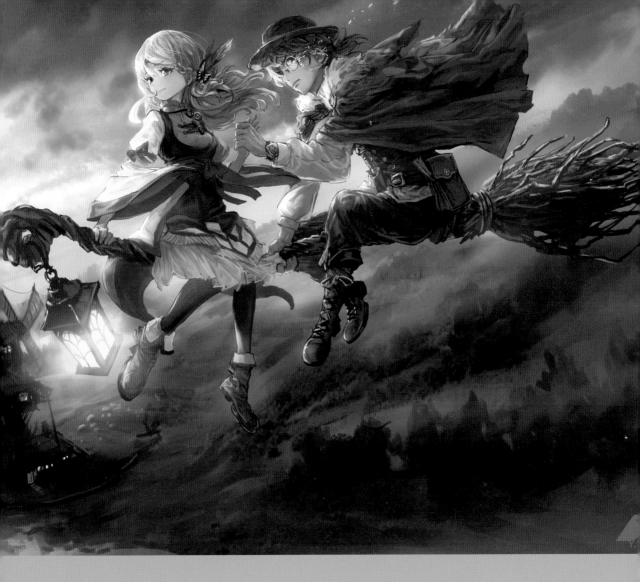

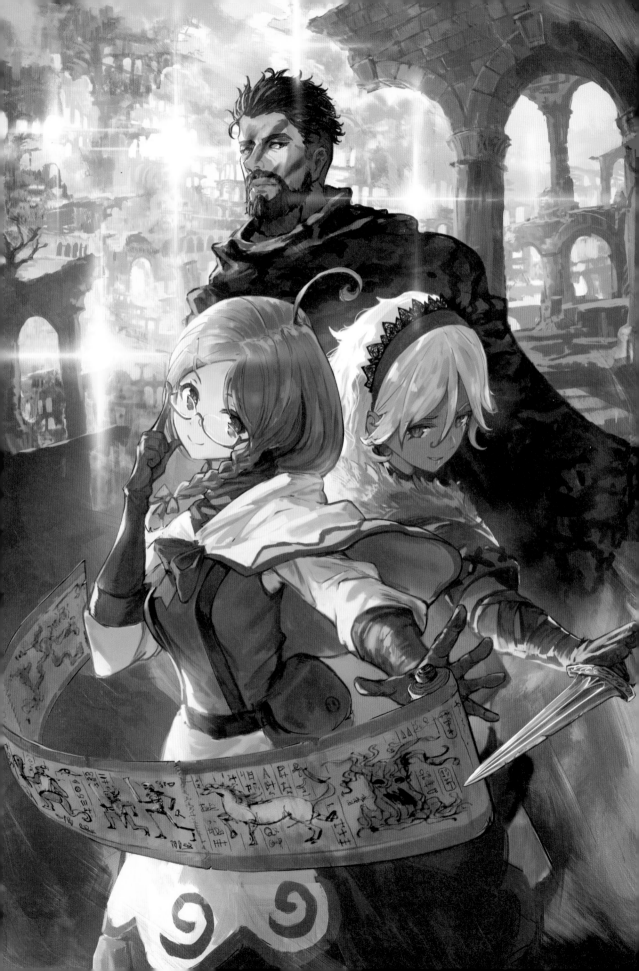

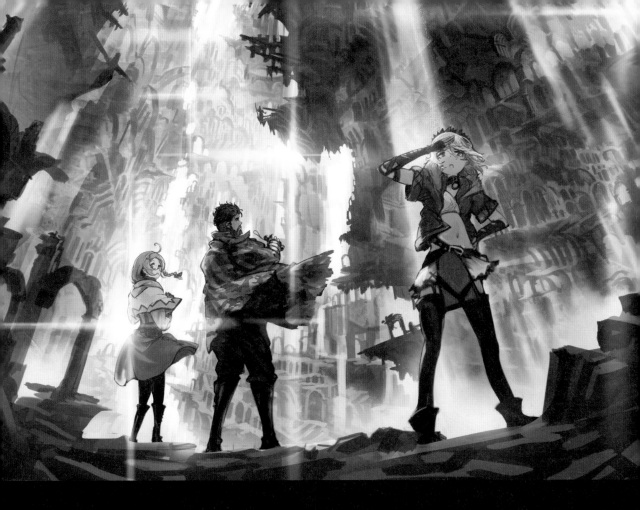

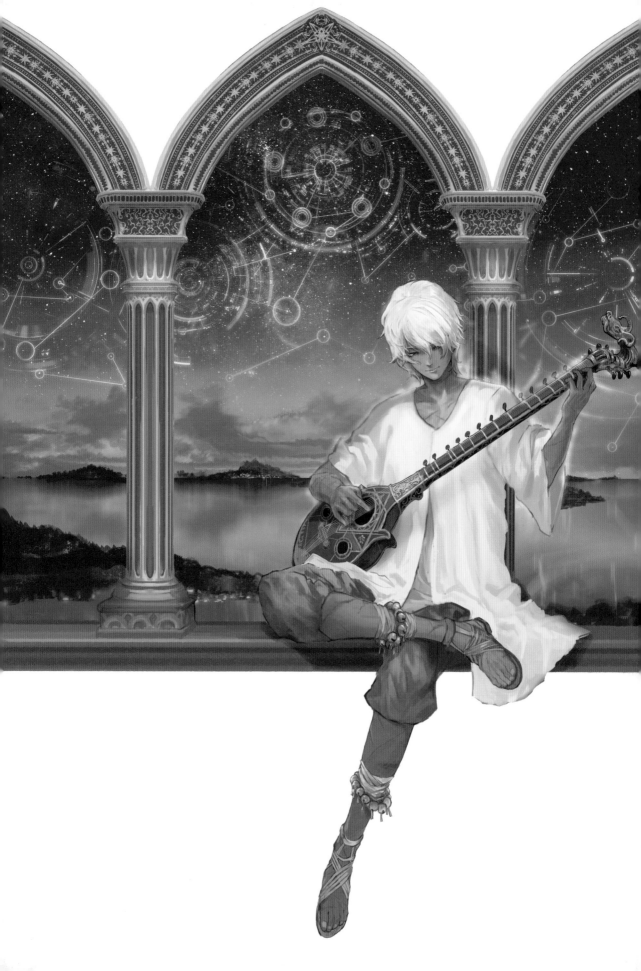

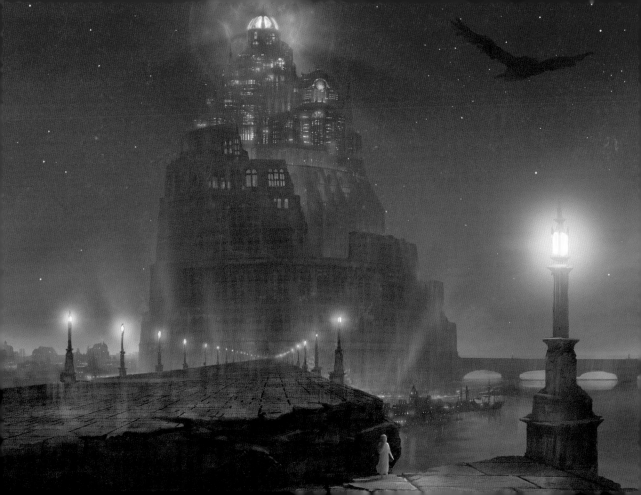

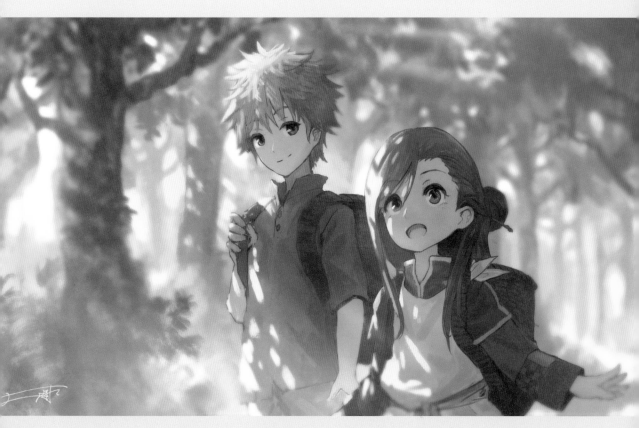

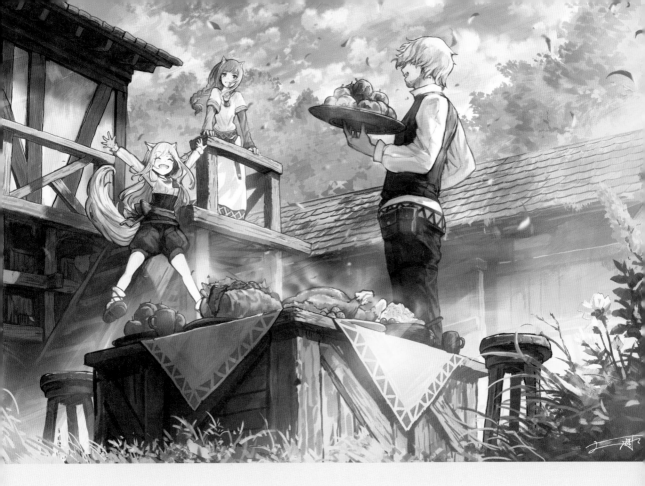

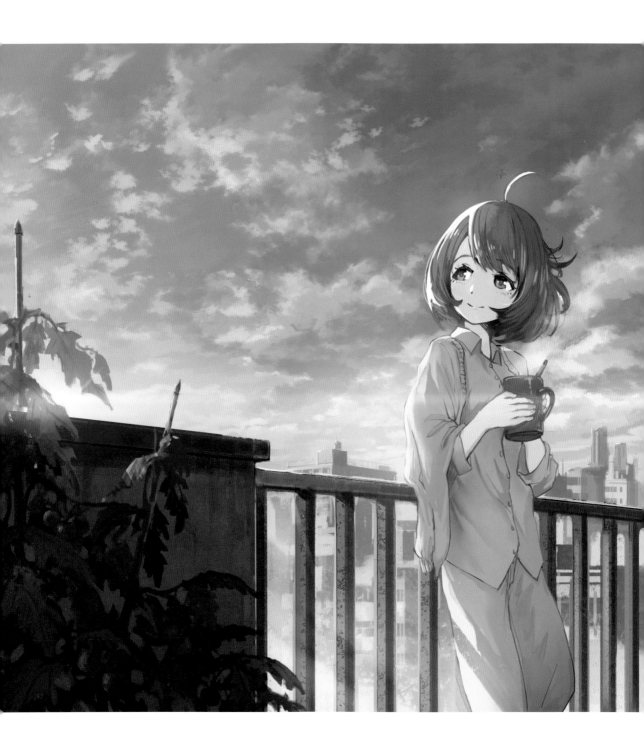

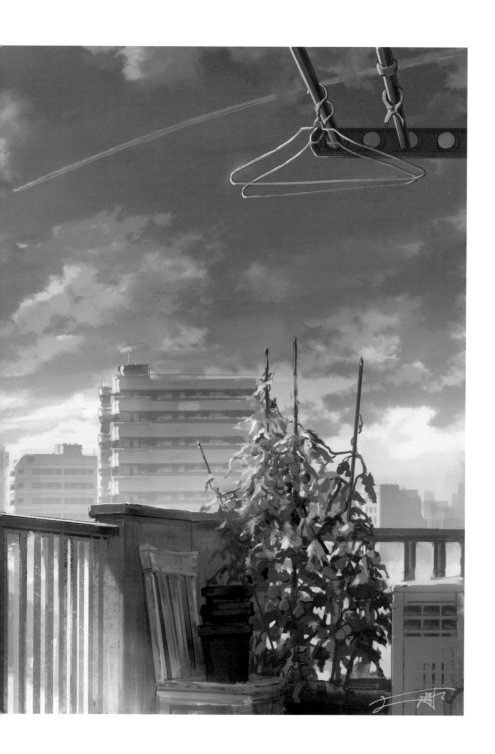

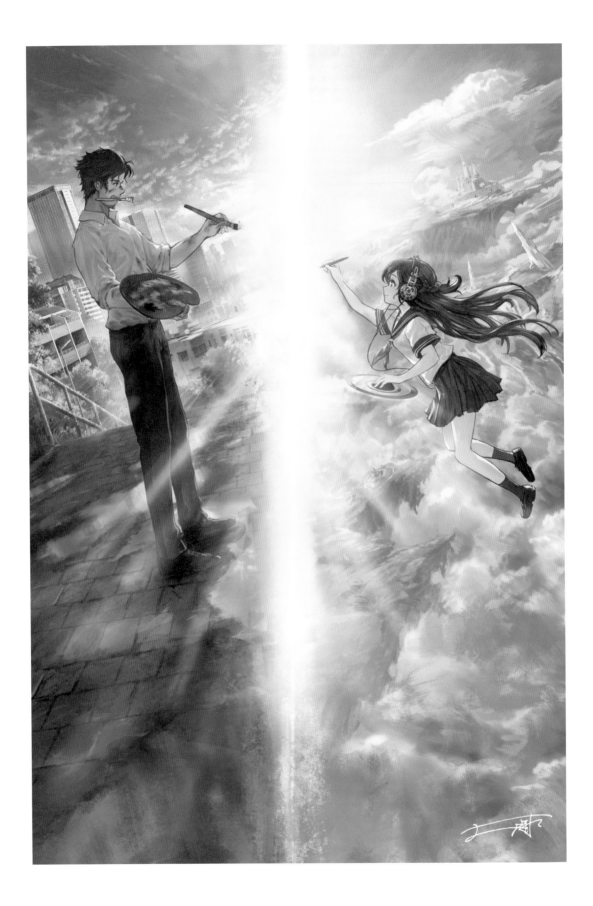

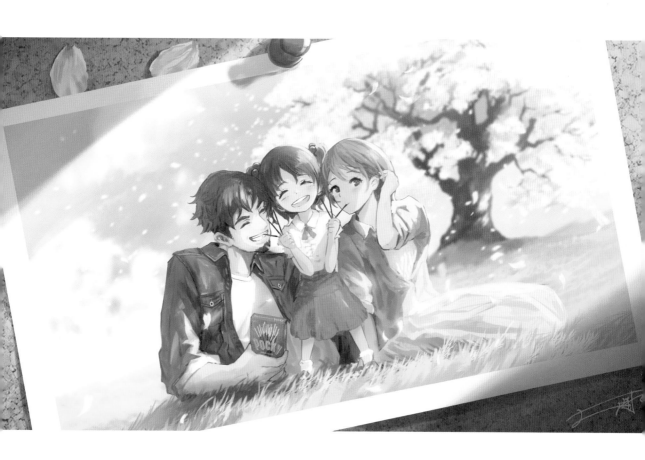

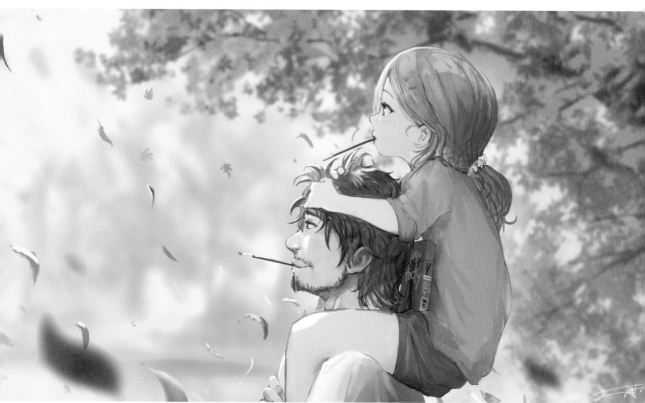

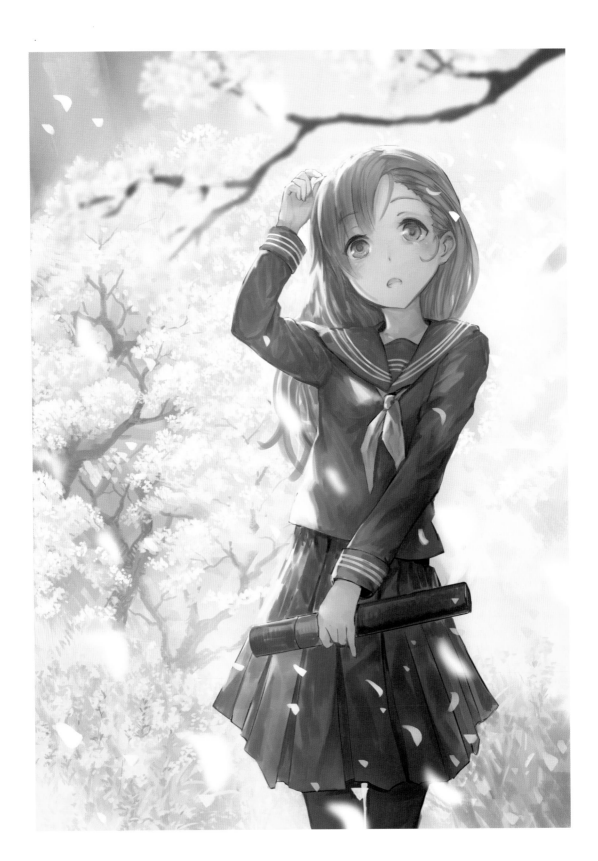

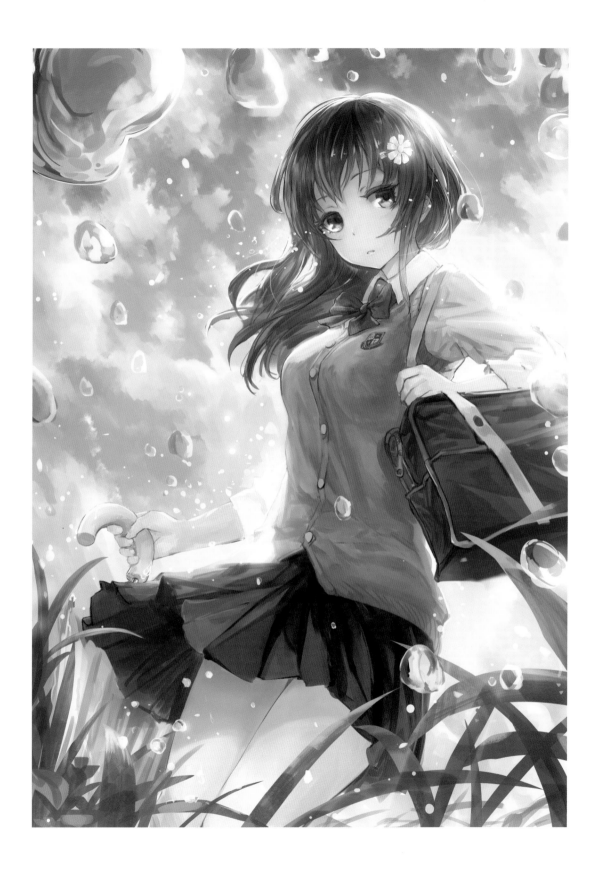

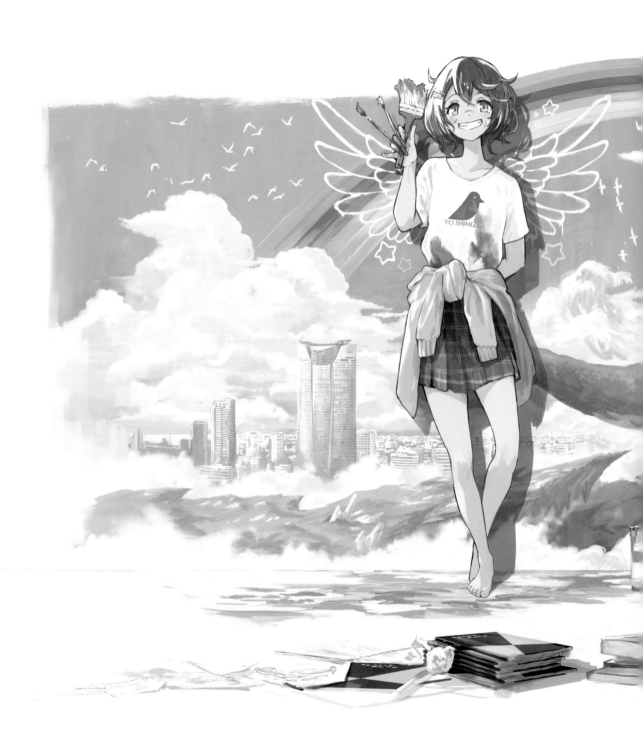

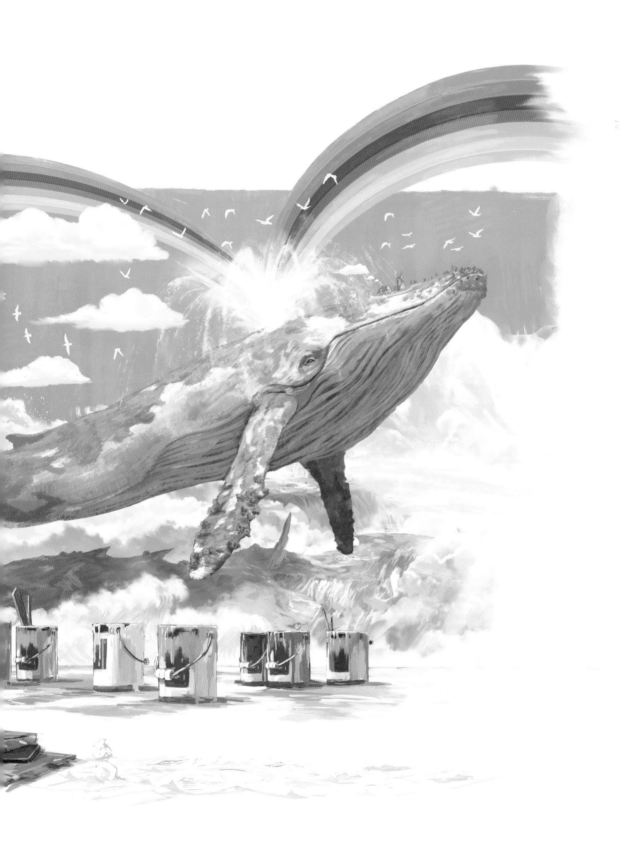

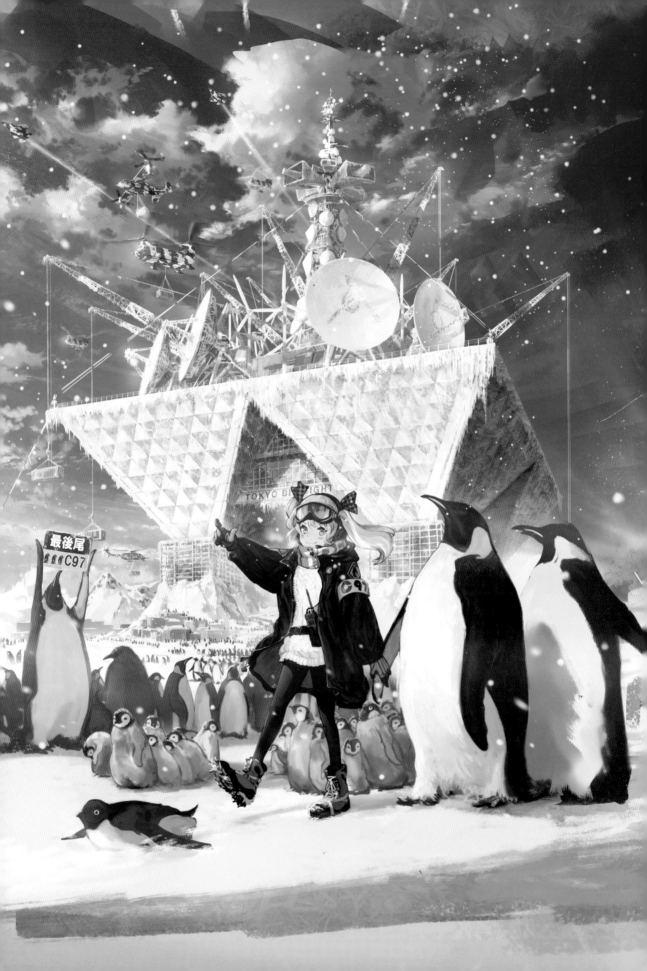

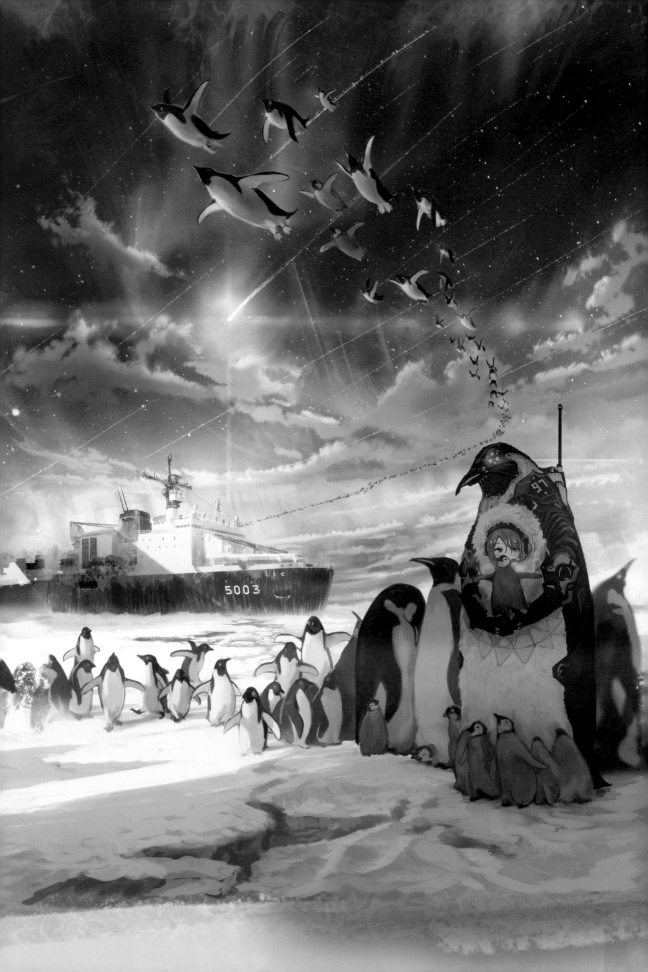

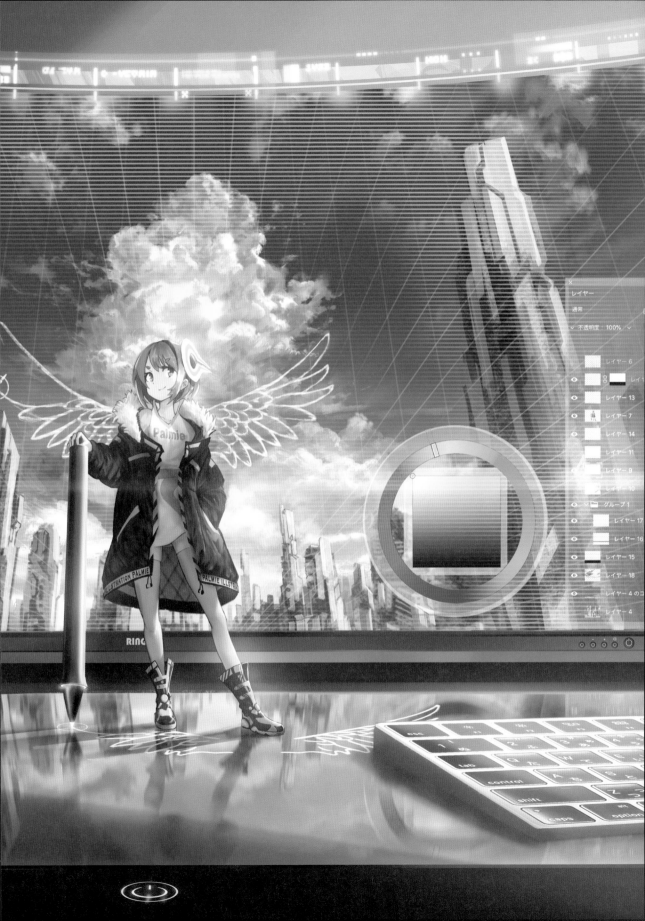

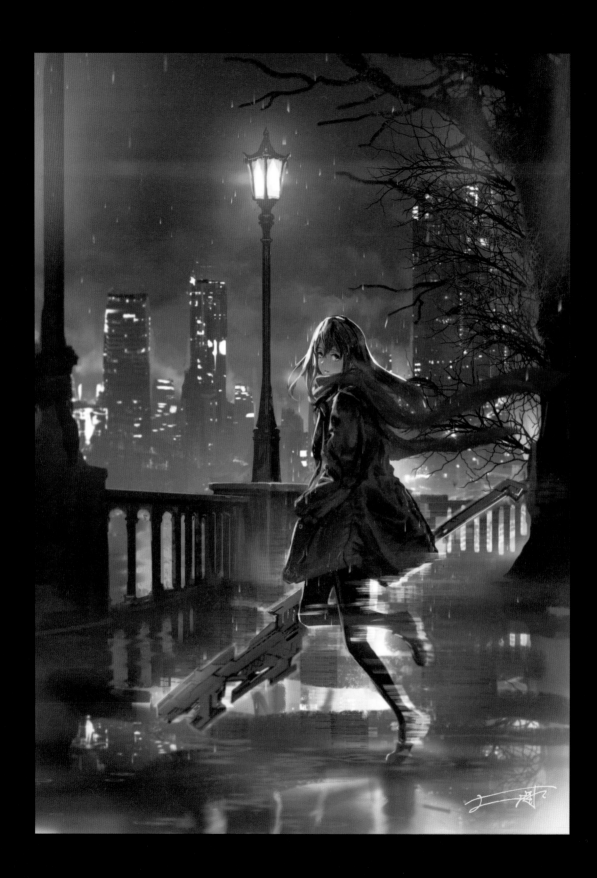

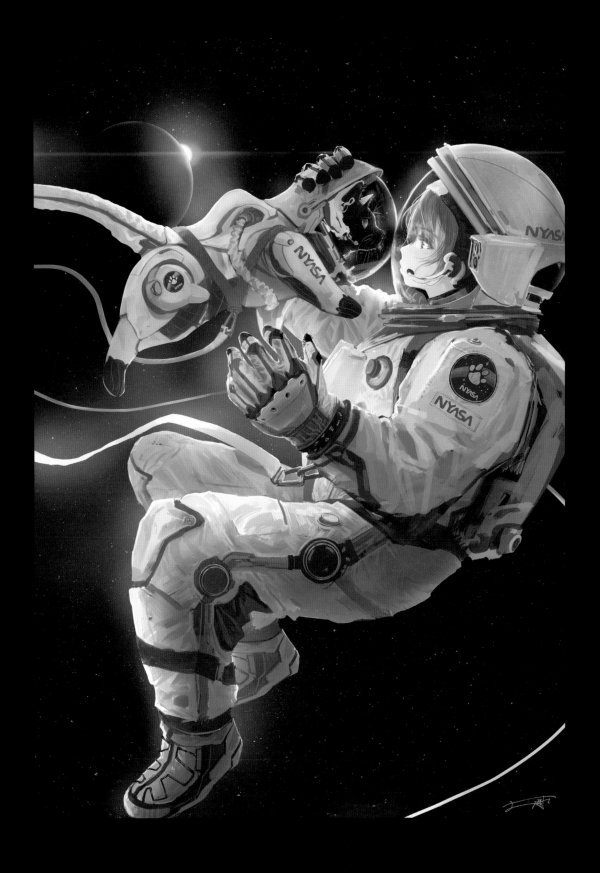

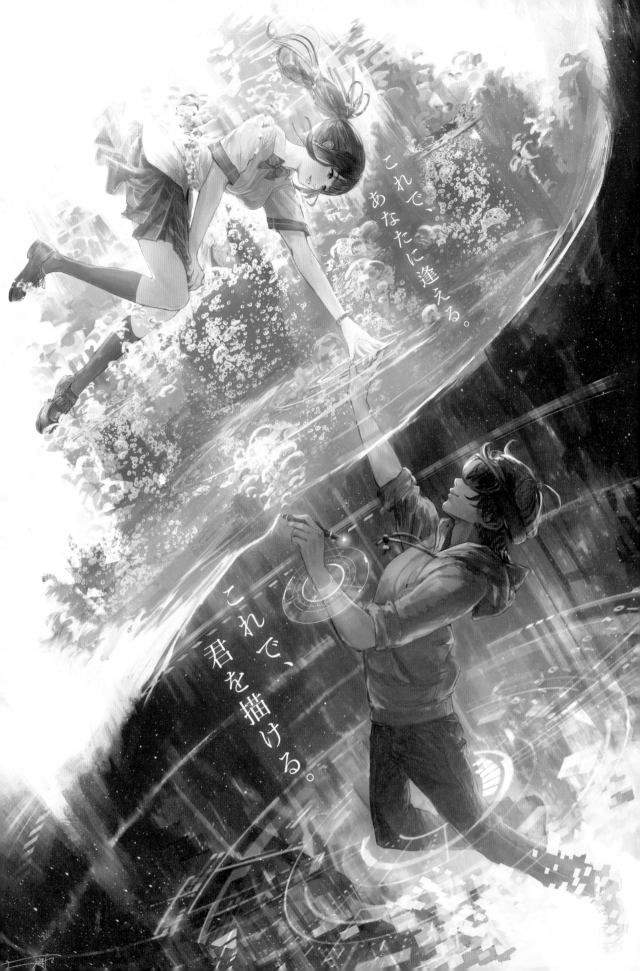

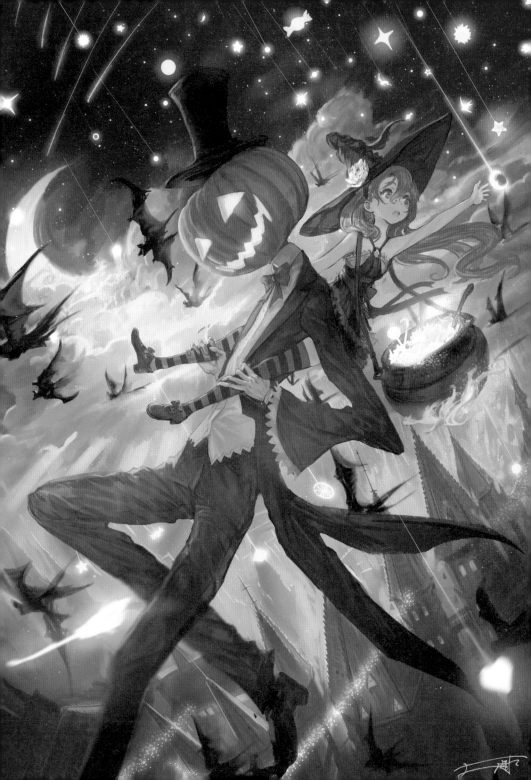

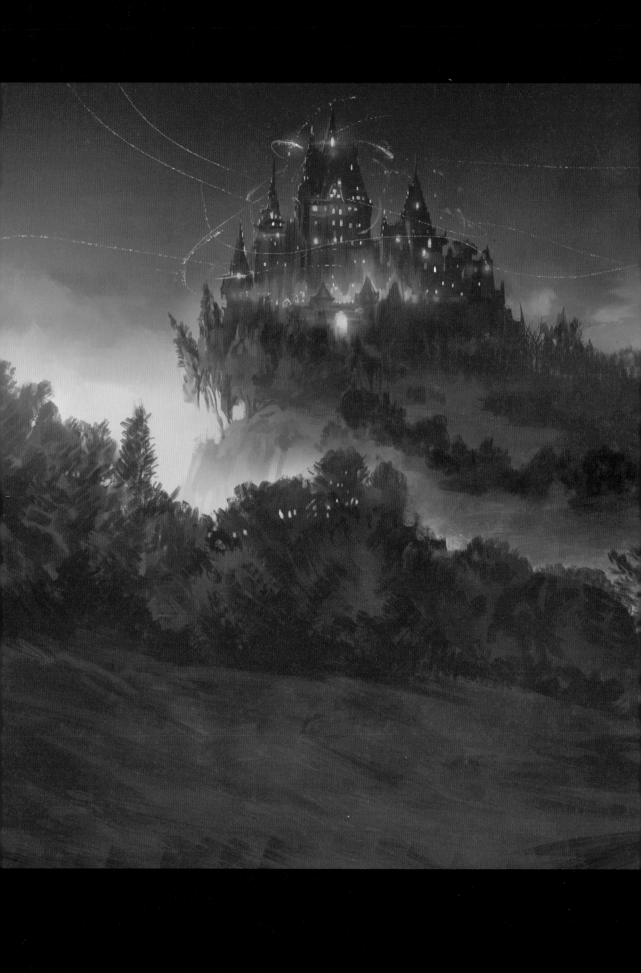

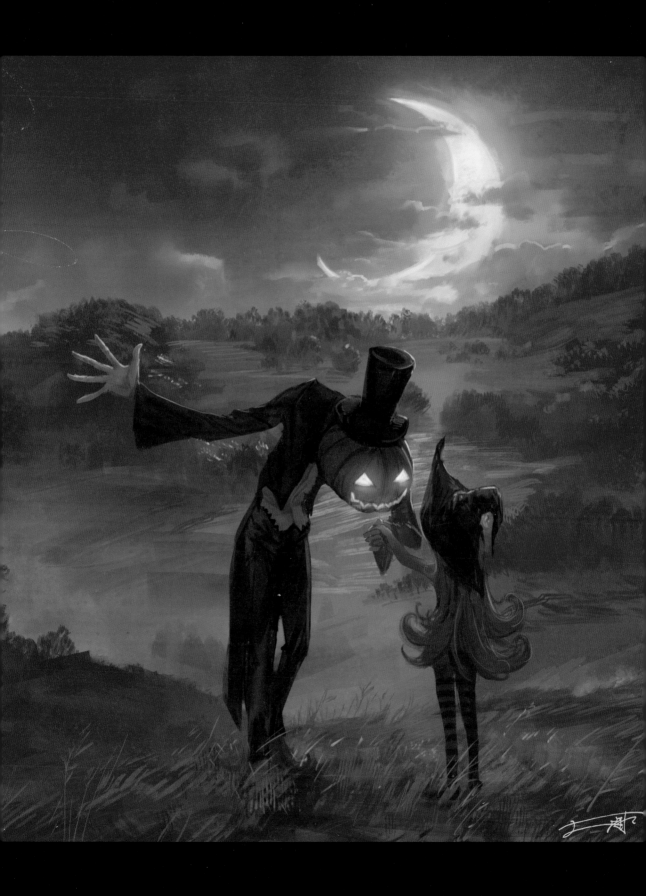

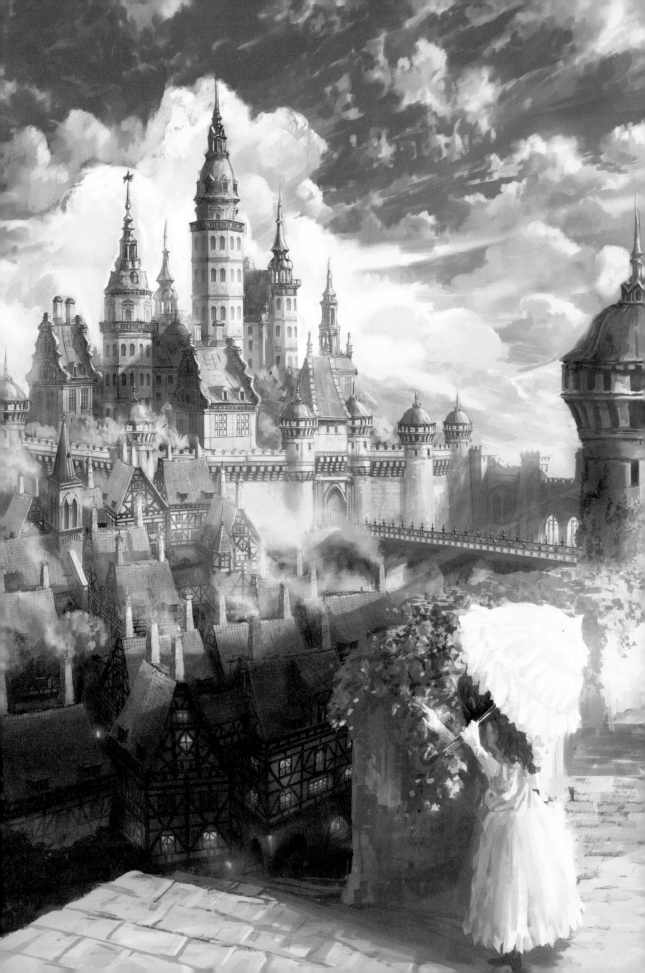

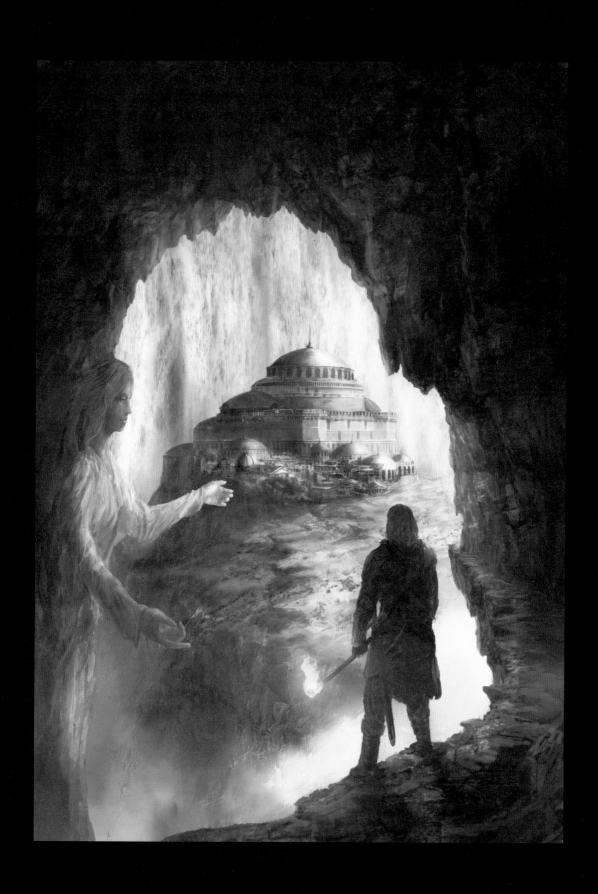

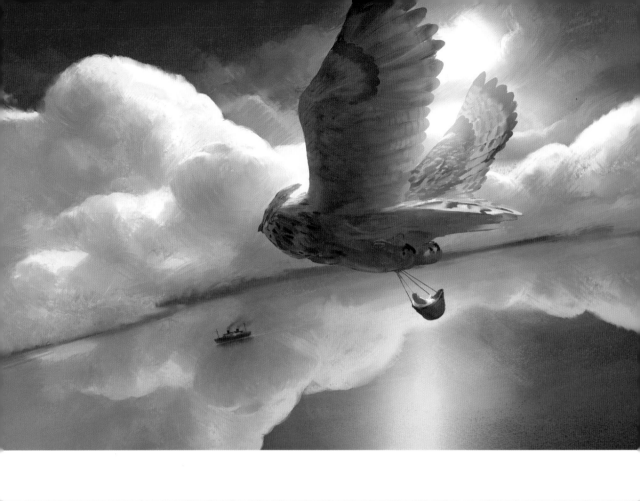

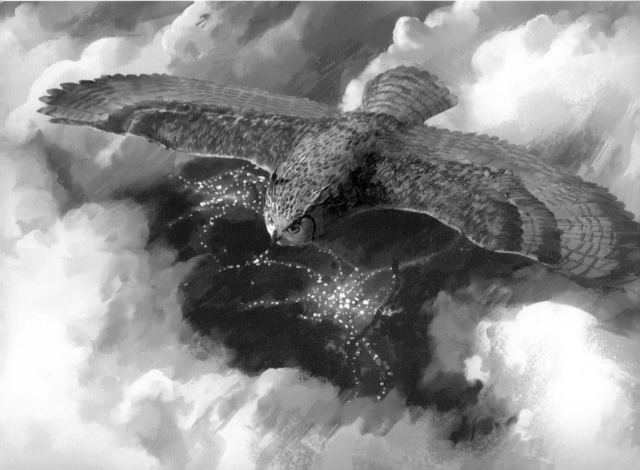

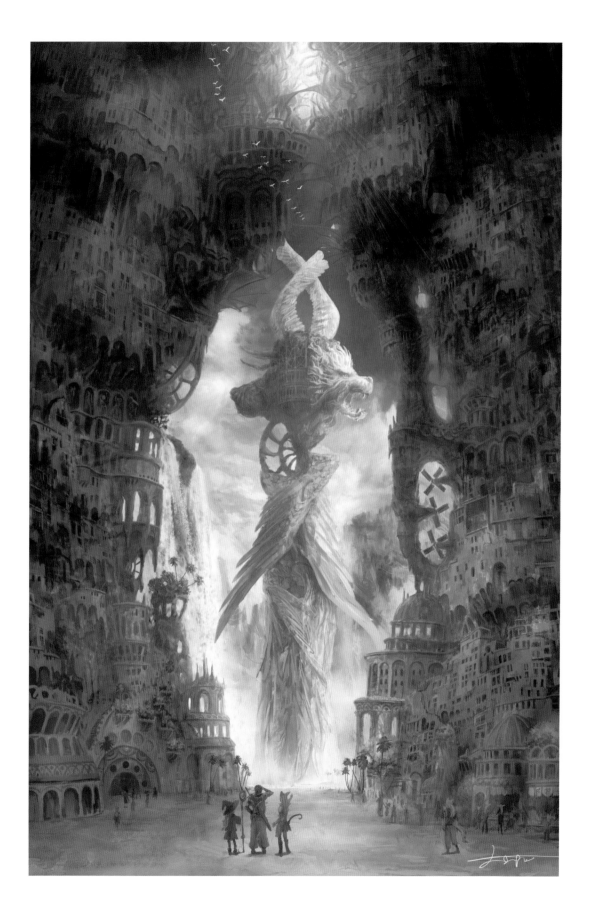

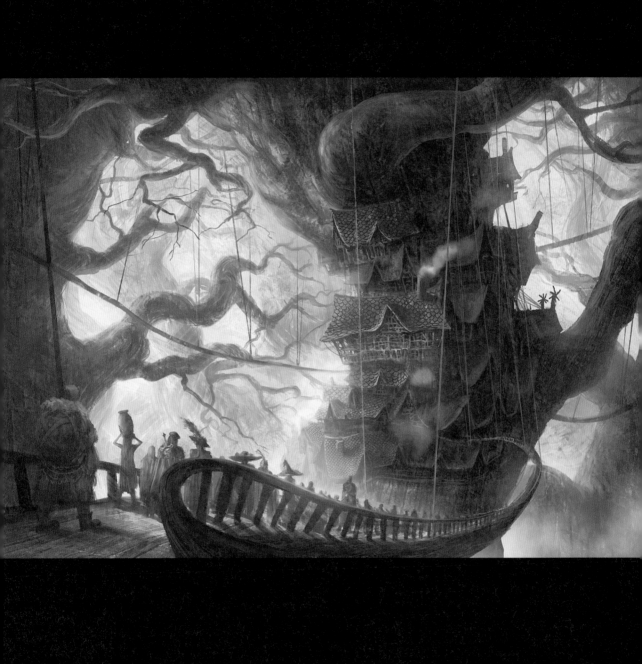

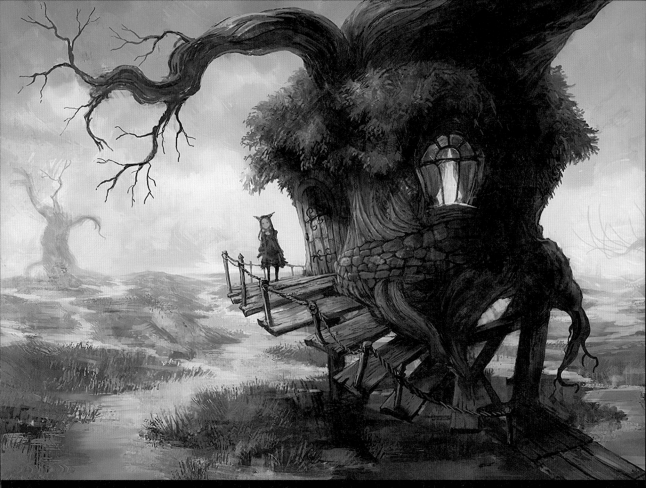

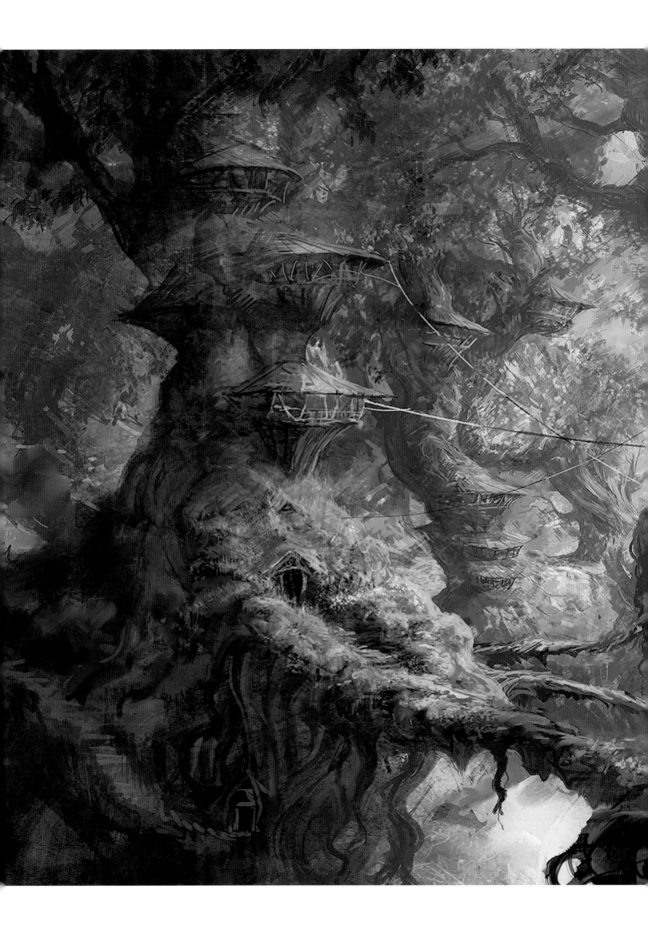

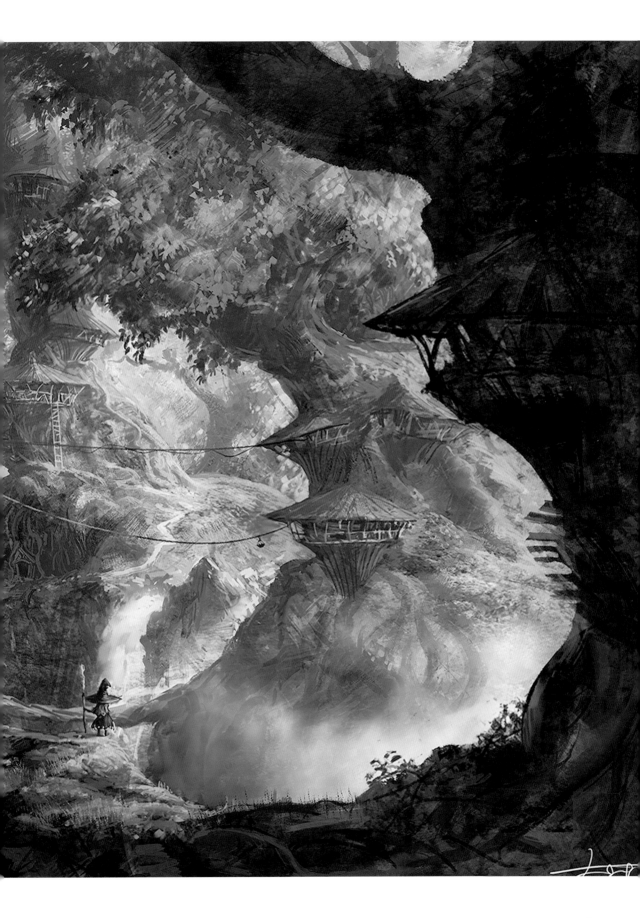

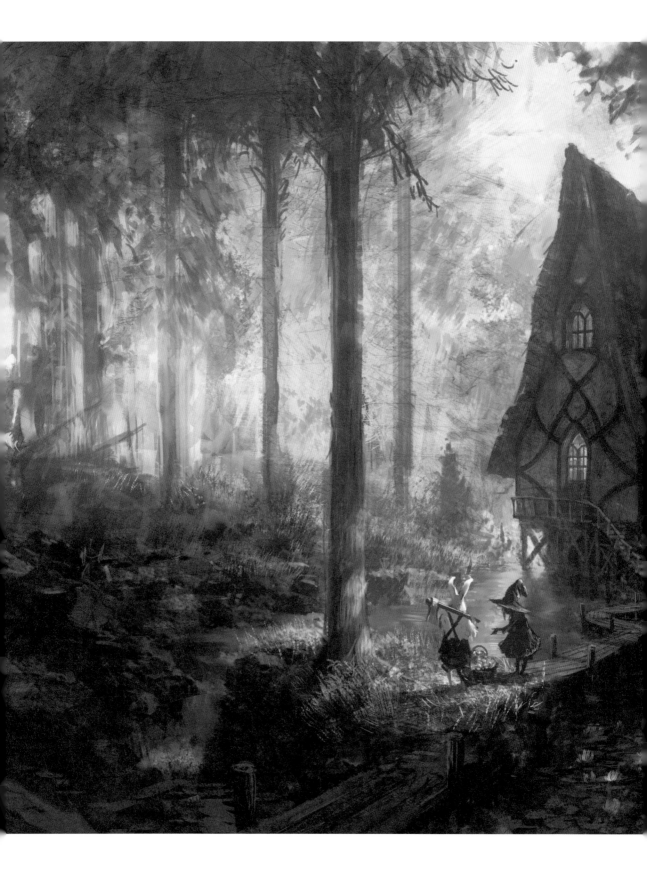

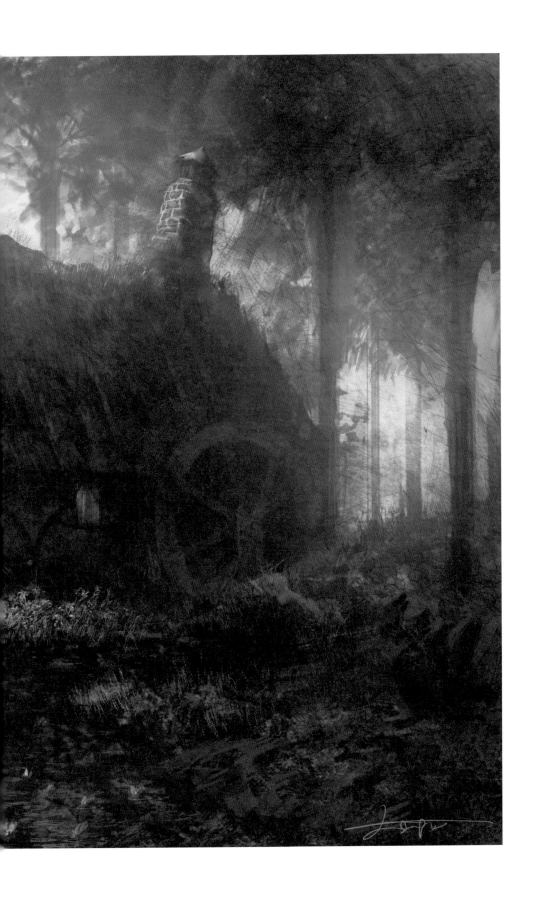

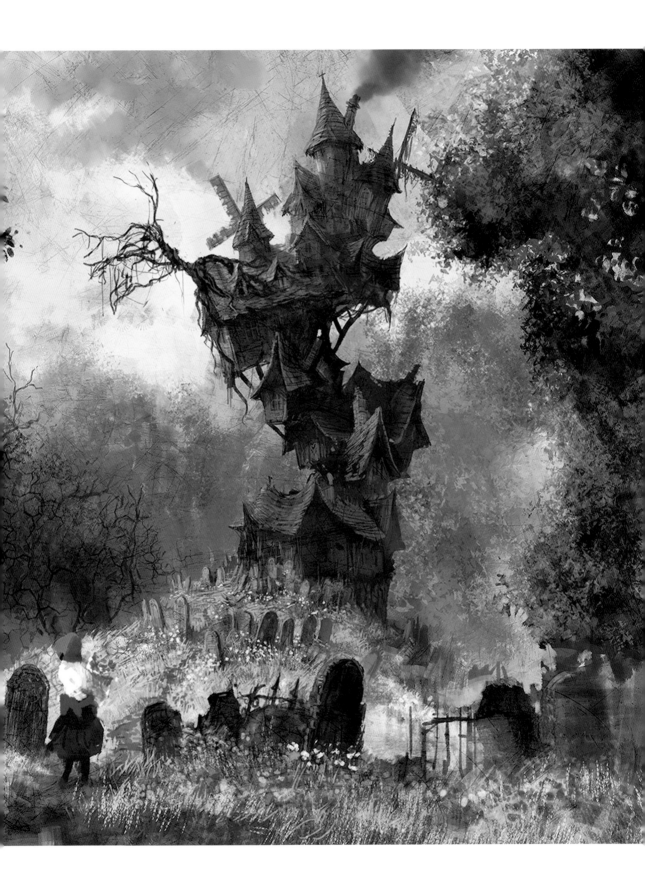

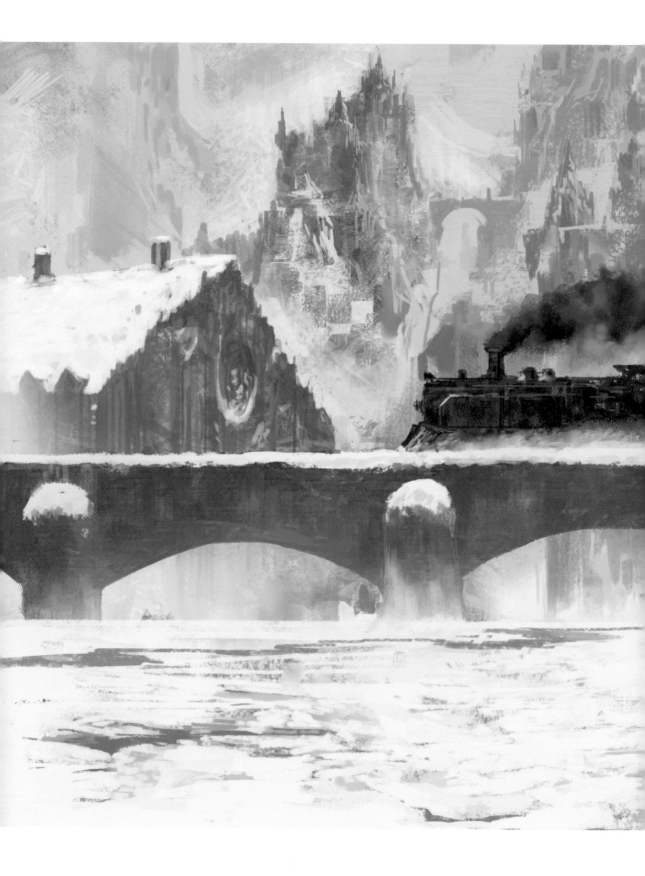

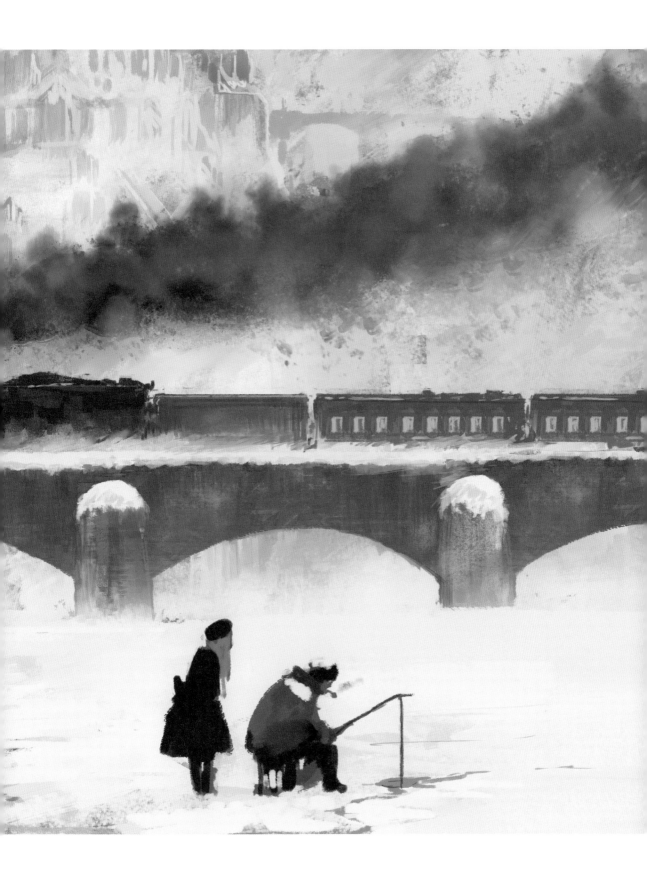

03



FANTASY AND ADVENTURE

ファンタジーと冒険。光と闇で描かれる魅力的な世界と、そこで繰り広げられる予想を超える冒険や闘い。冒険はいくつになっても心躍ってしまいます。

Fantasy and adventure. I depict fascinating settings through combinations of light and darkness, and let all kinds of unexpected adventures and battles take place in them. Regardless of my age, I still find excitement in adventures.

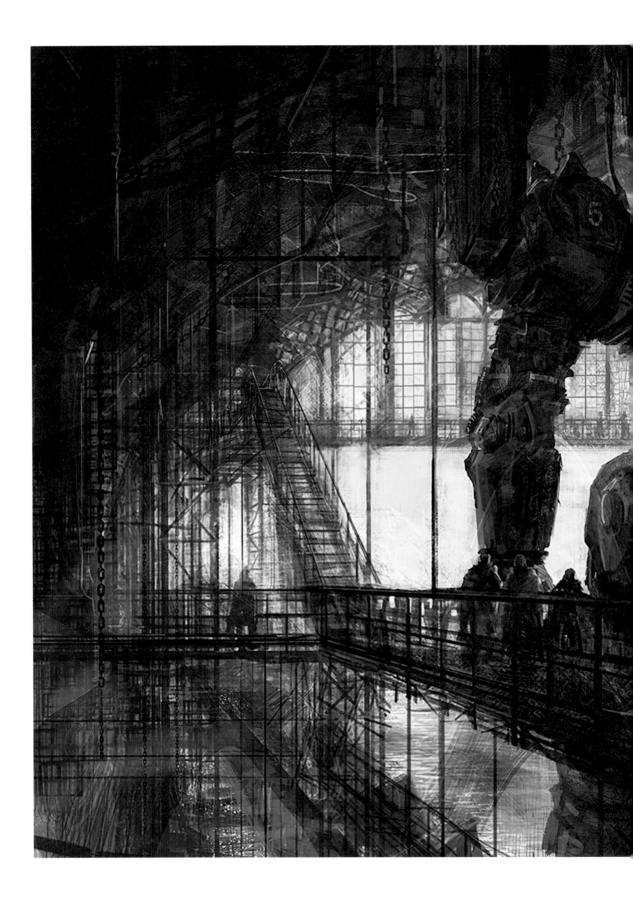

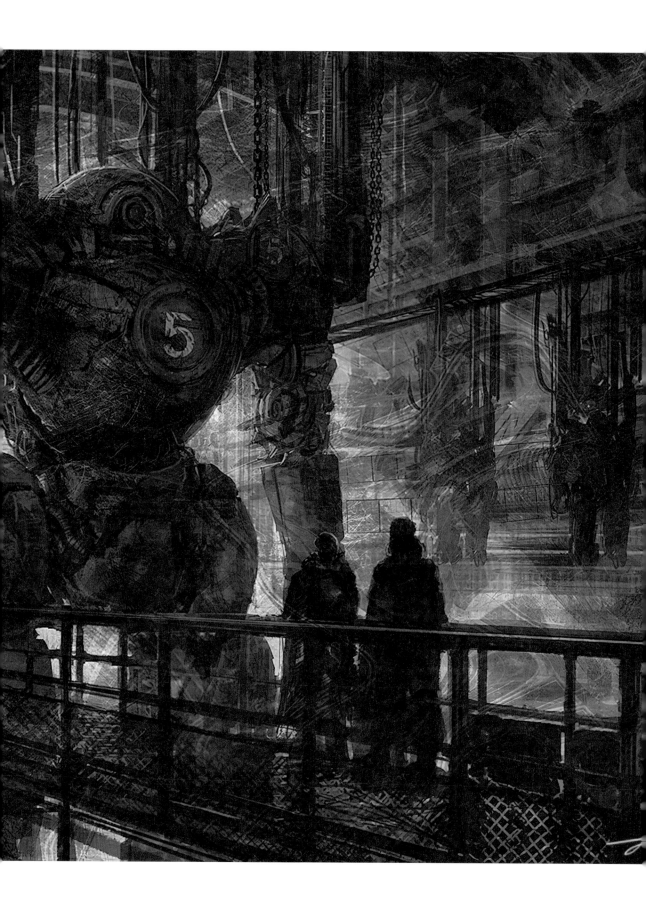

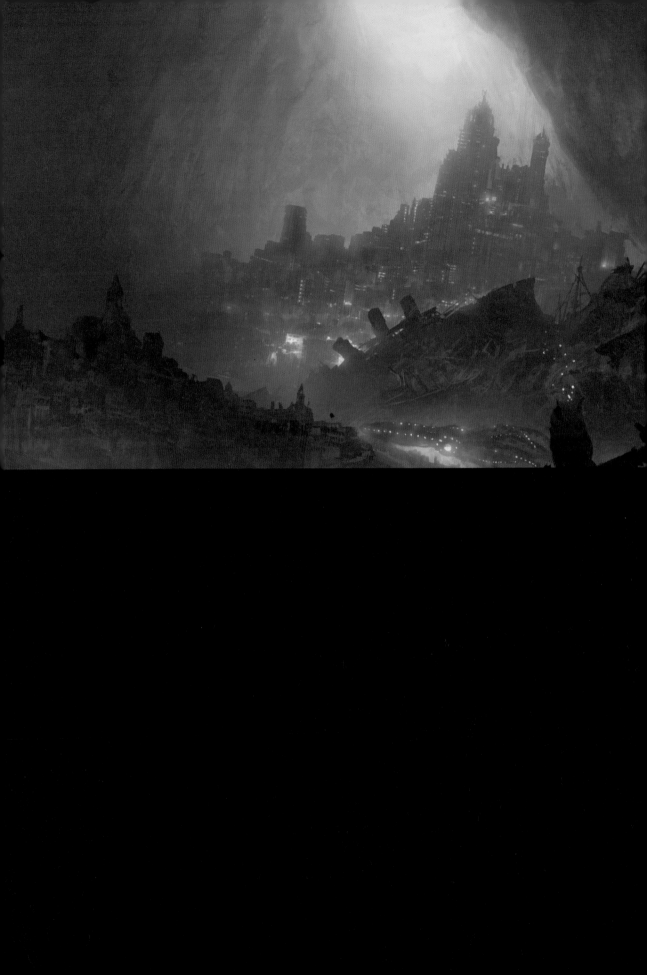

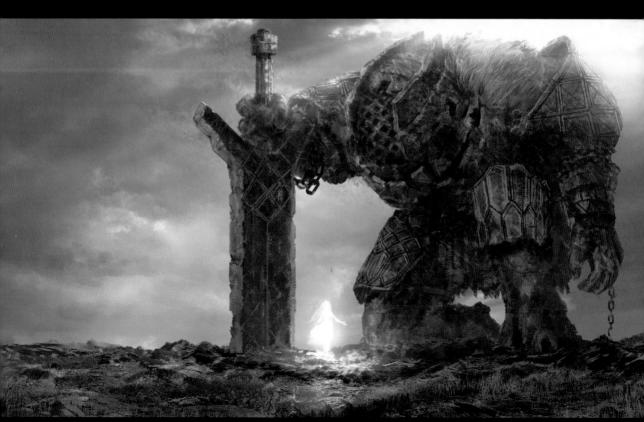

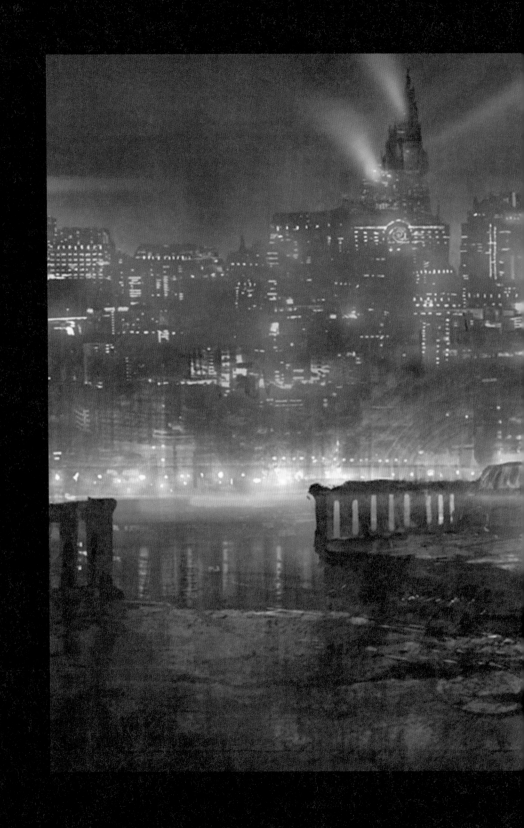

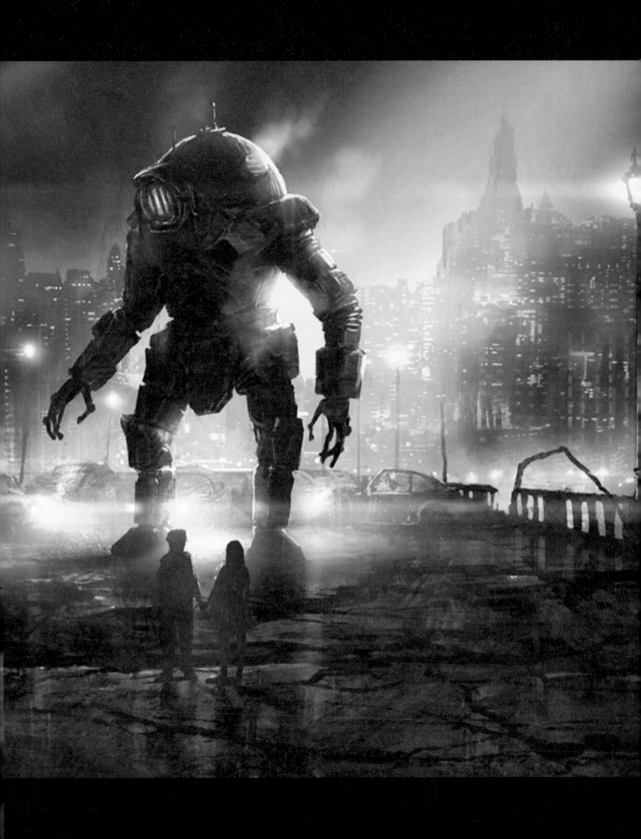

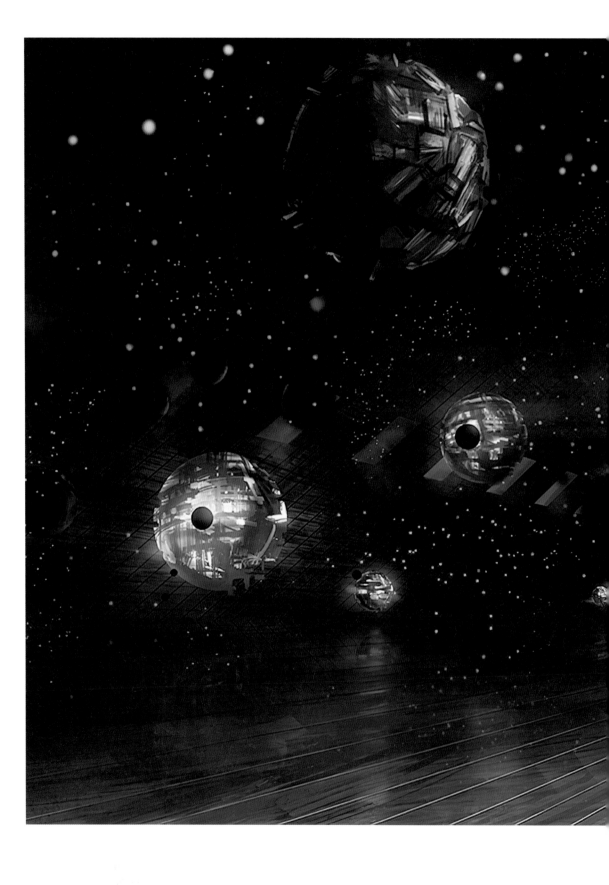

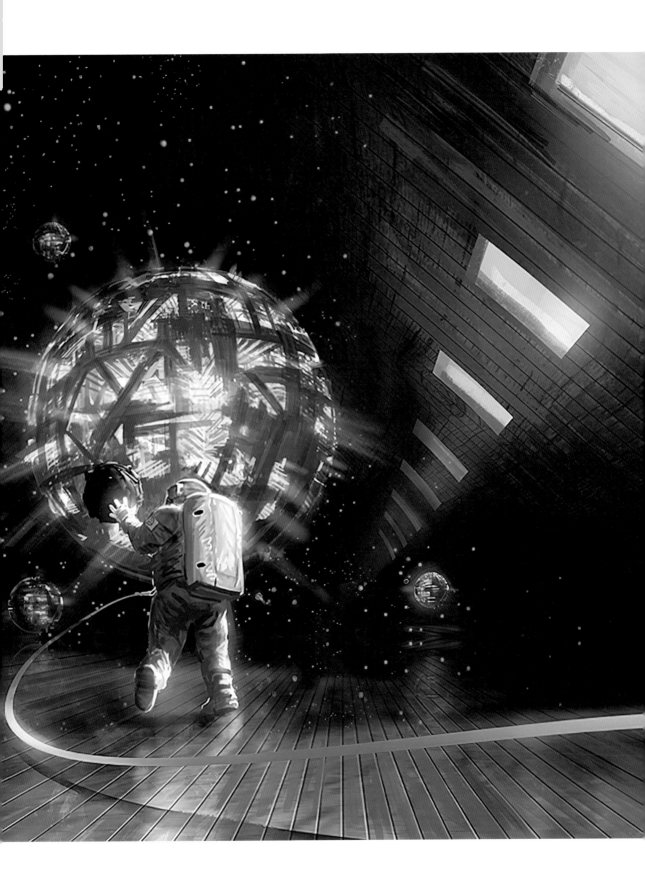

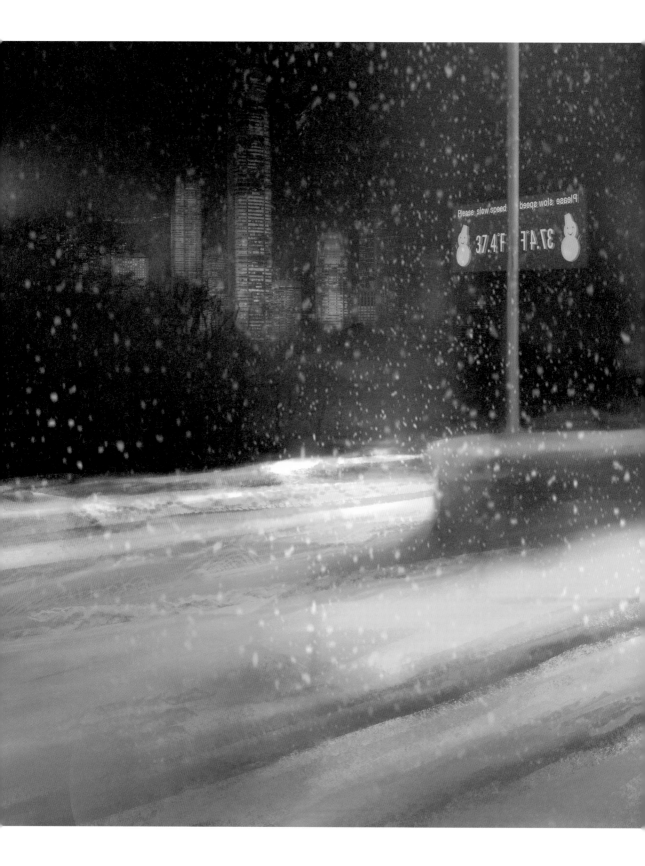

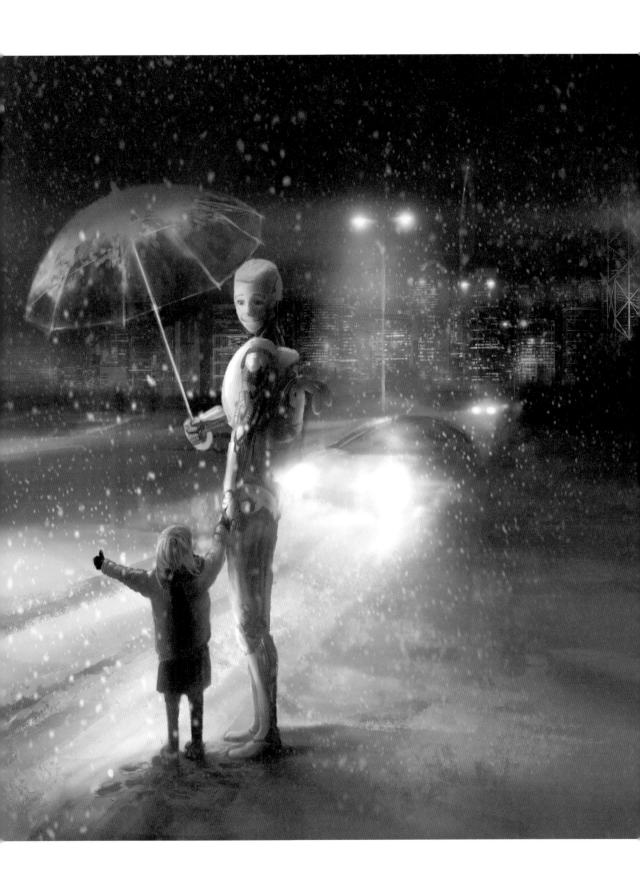

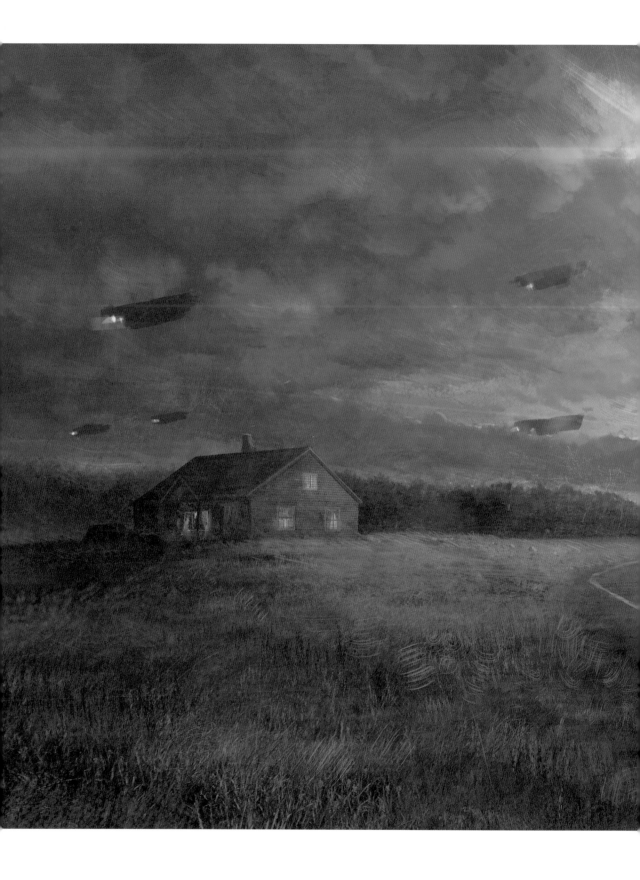

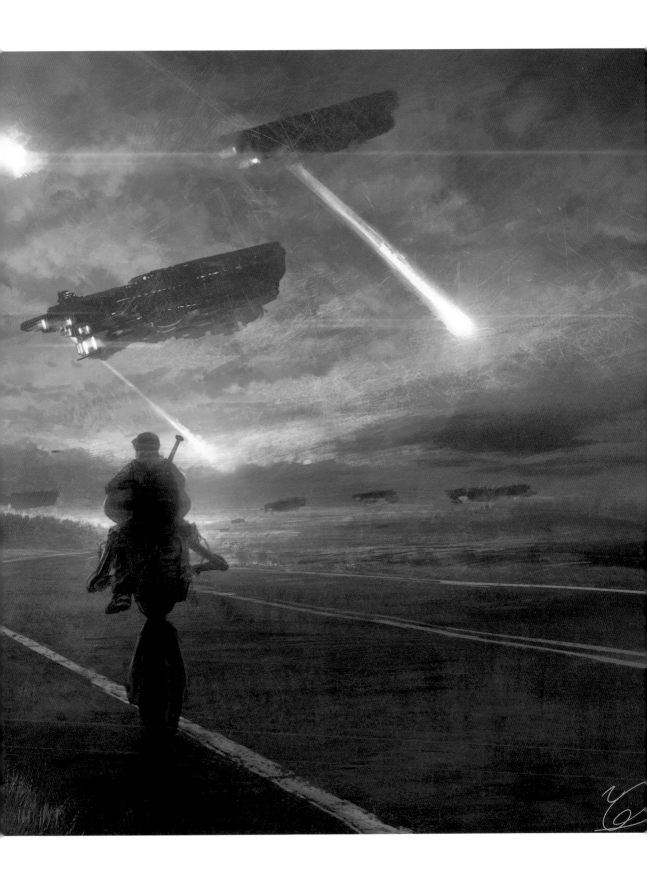

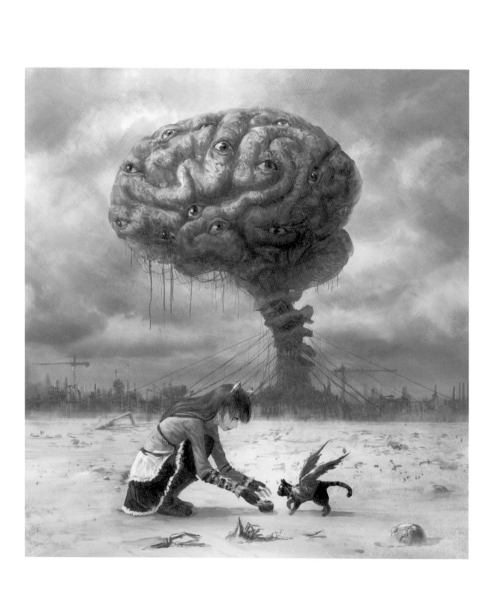

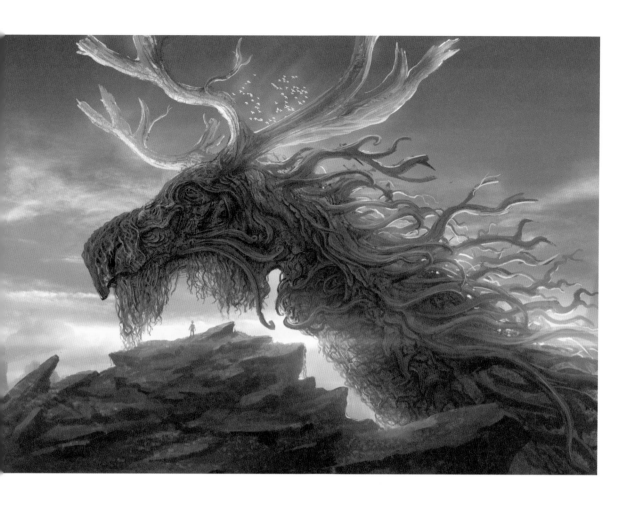

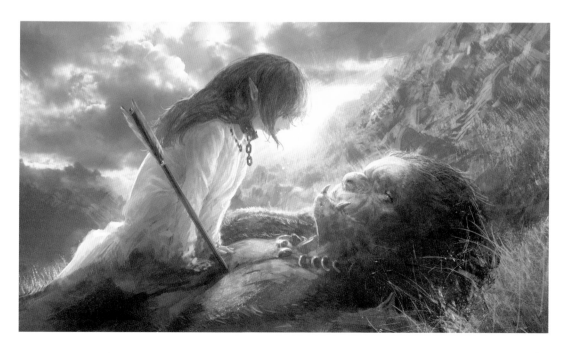

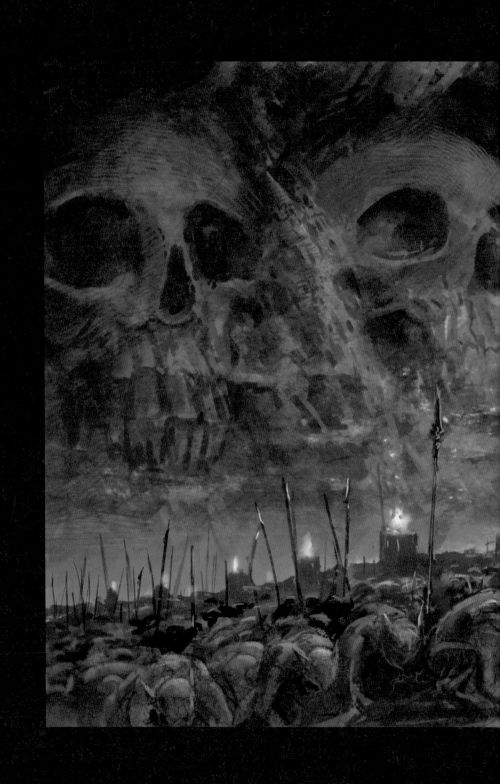

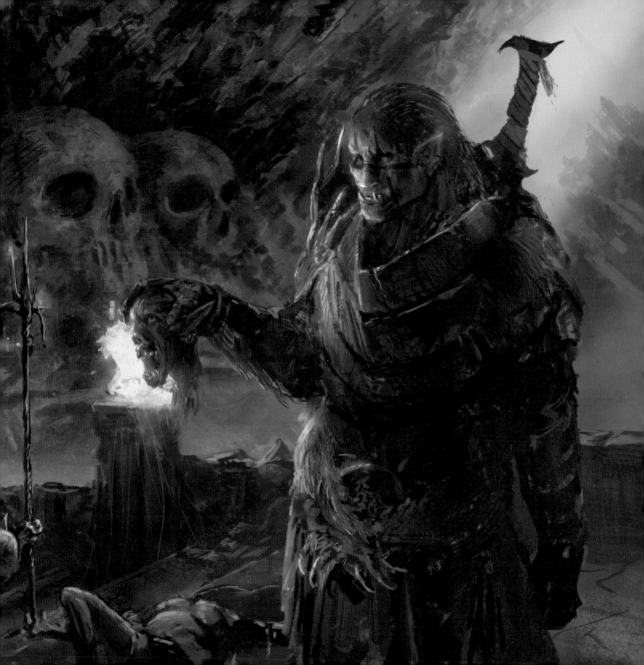

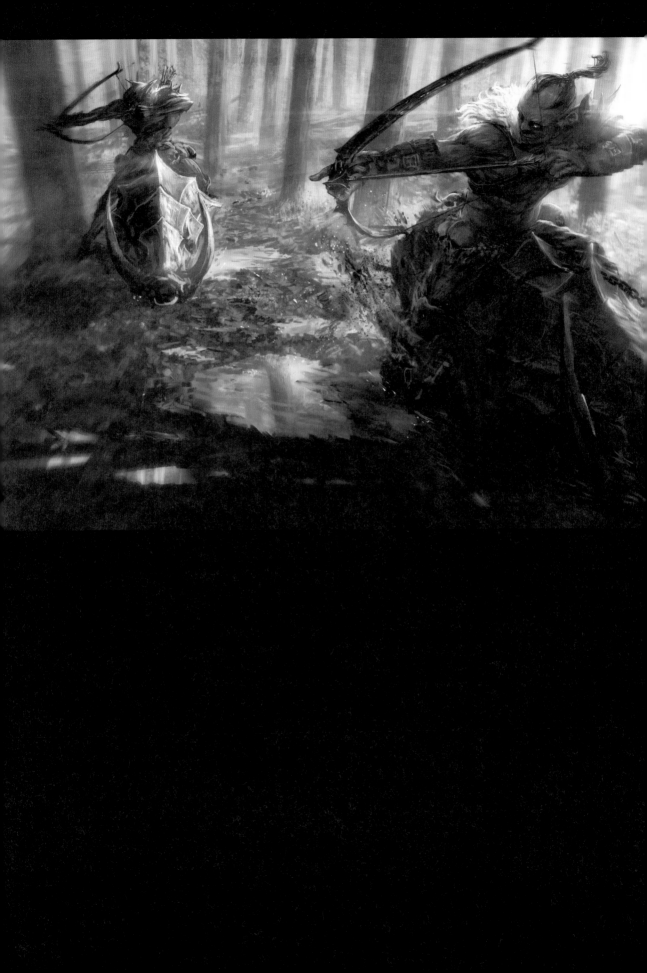

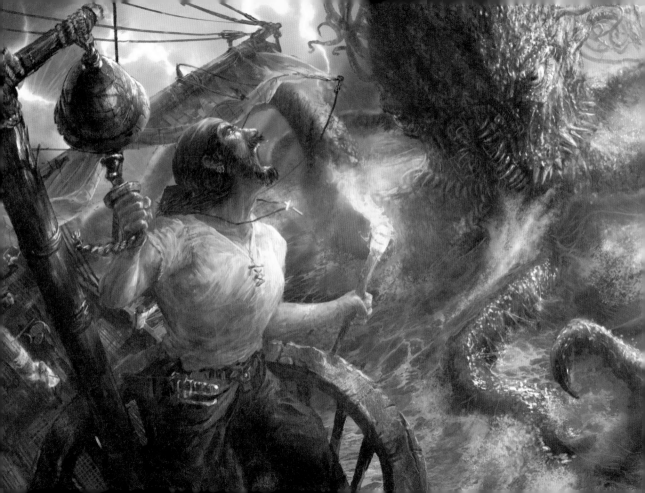

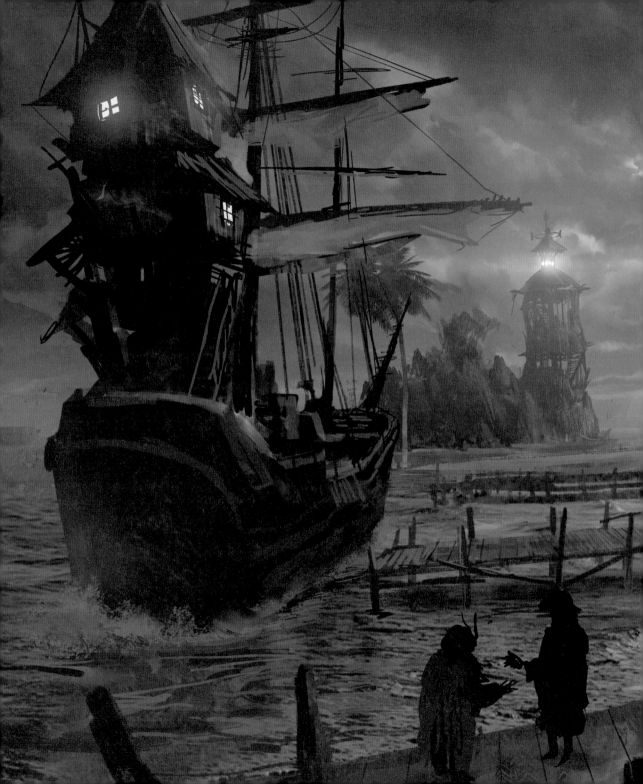

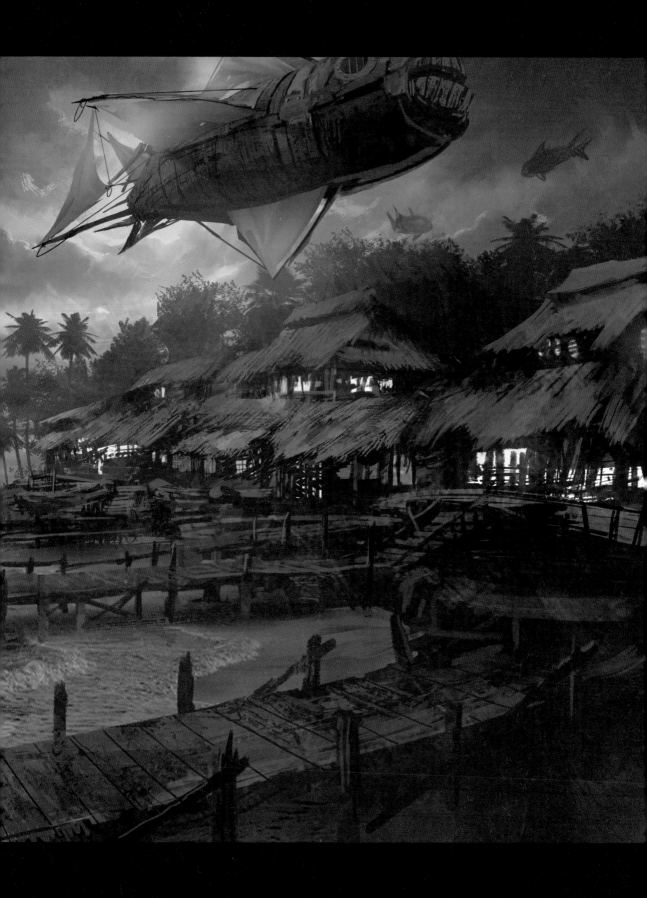

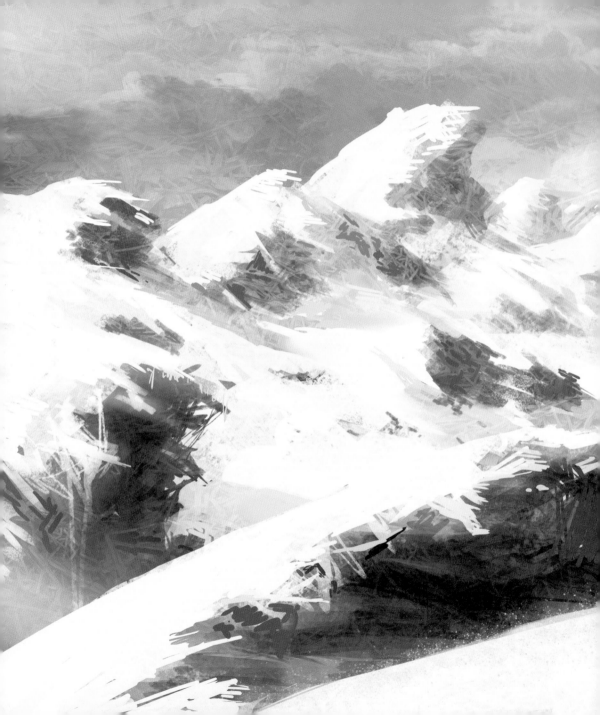

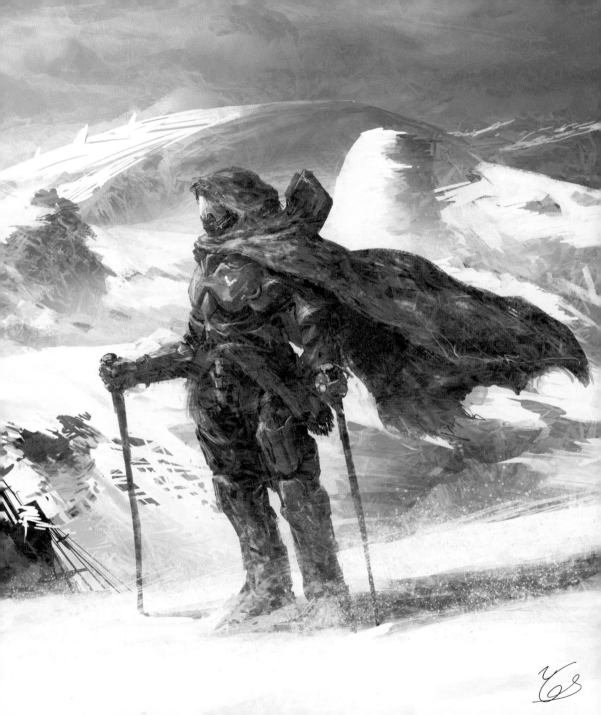

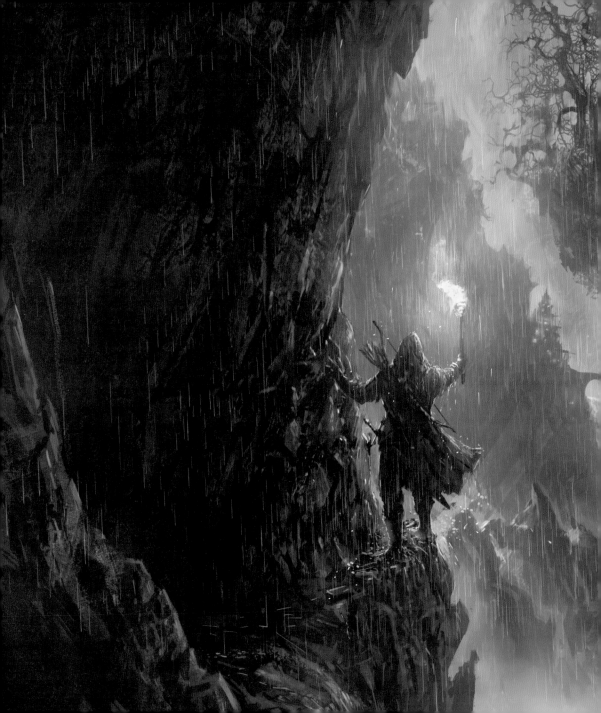

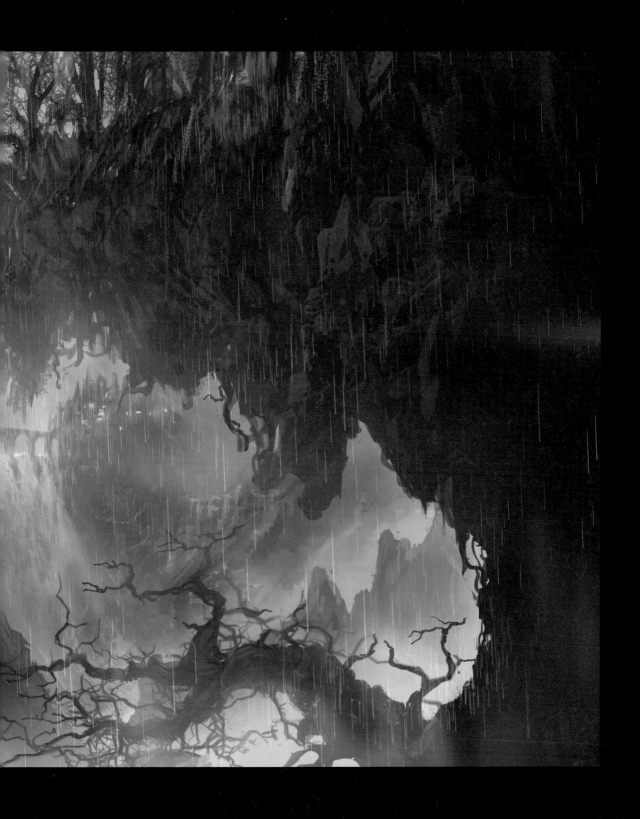

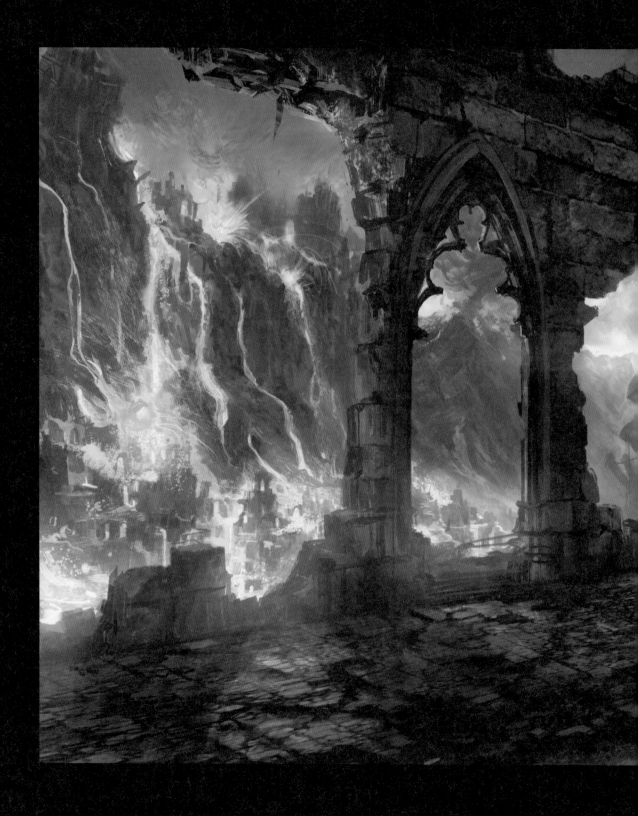

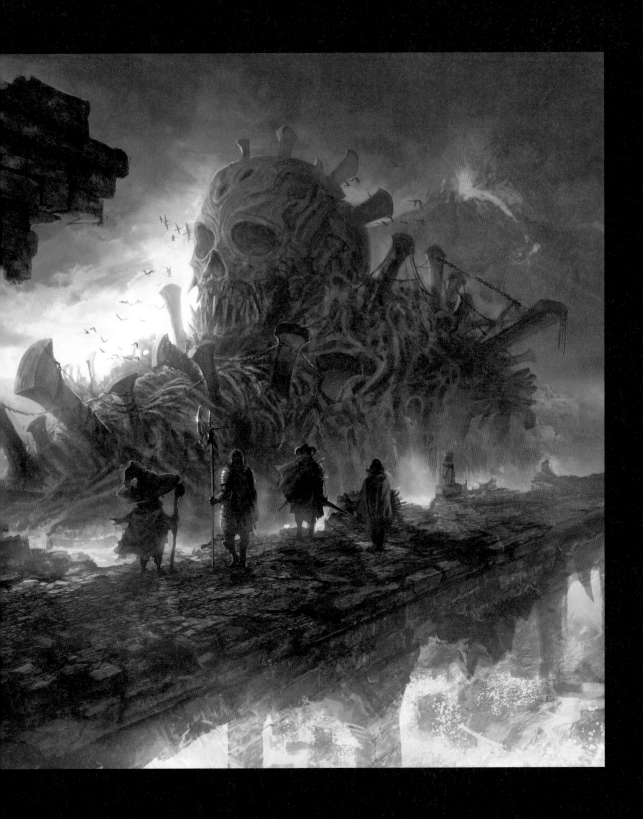

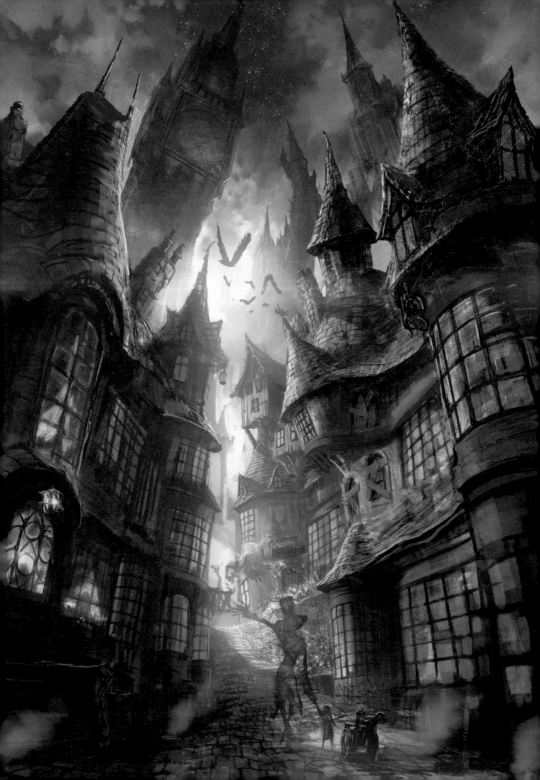

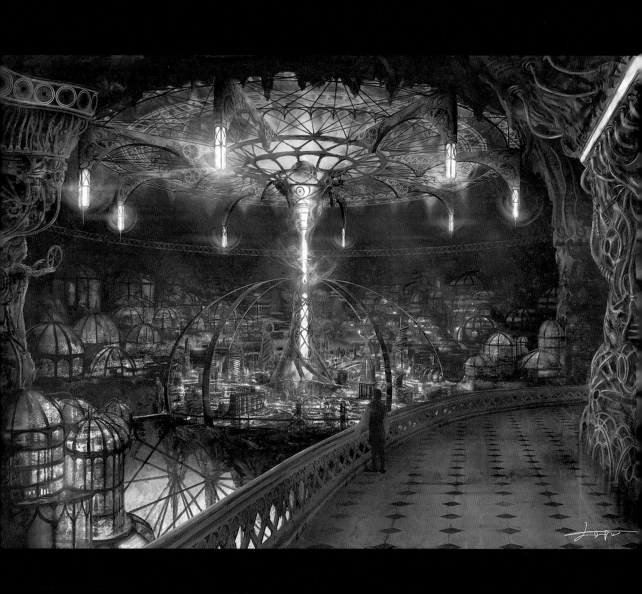

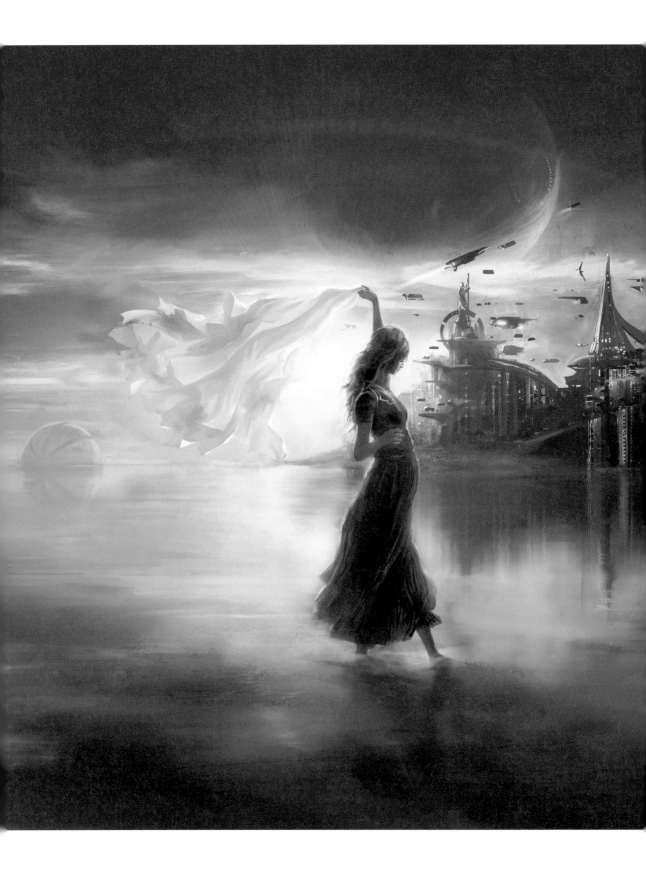

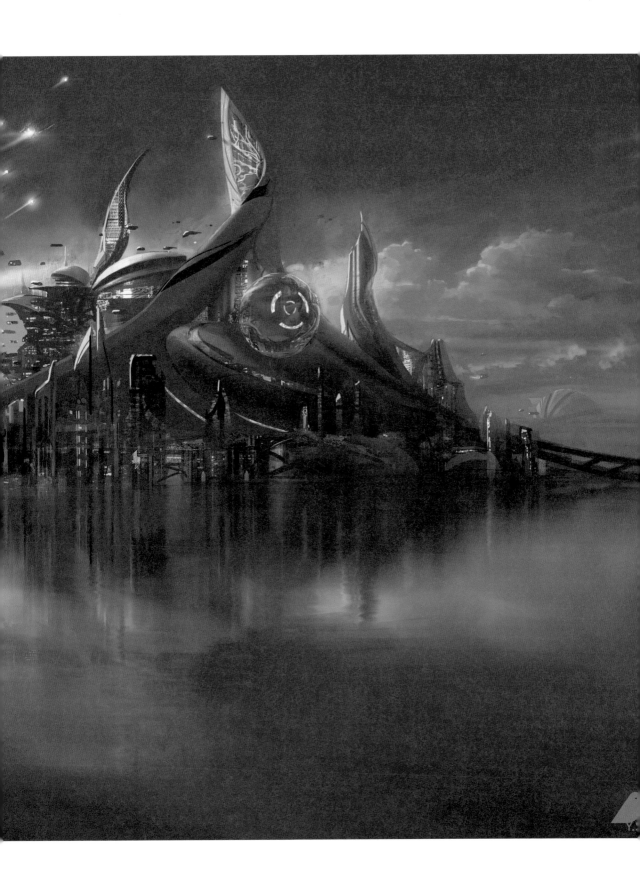

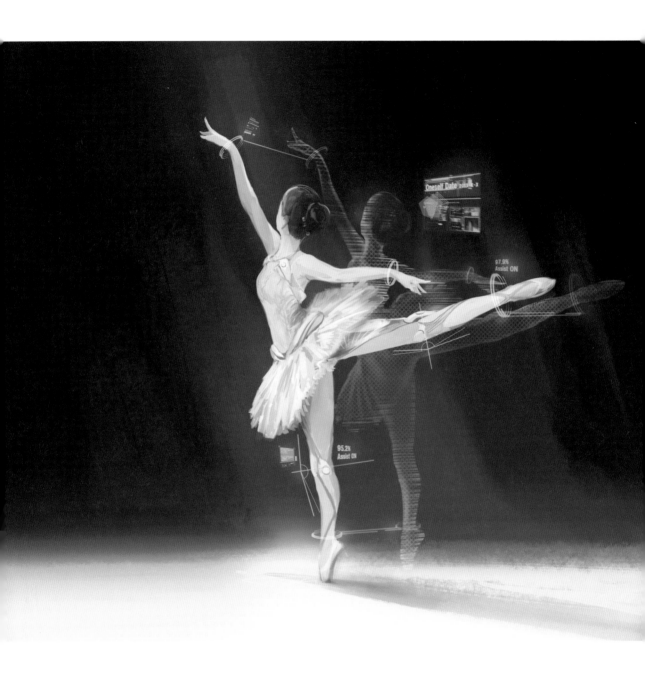

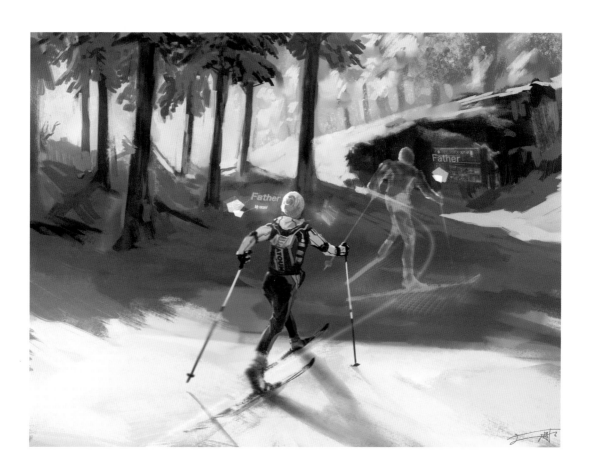

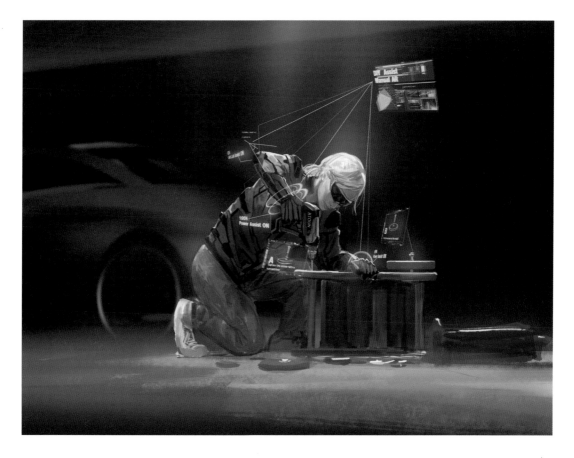

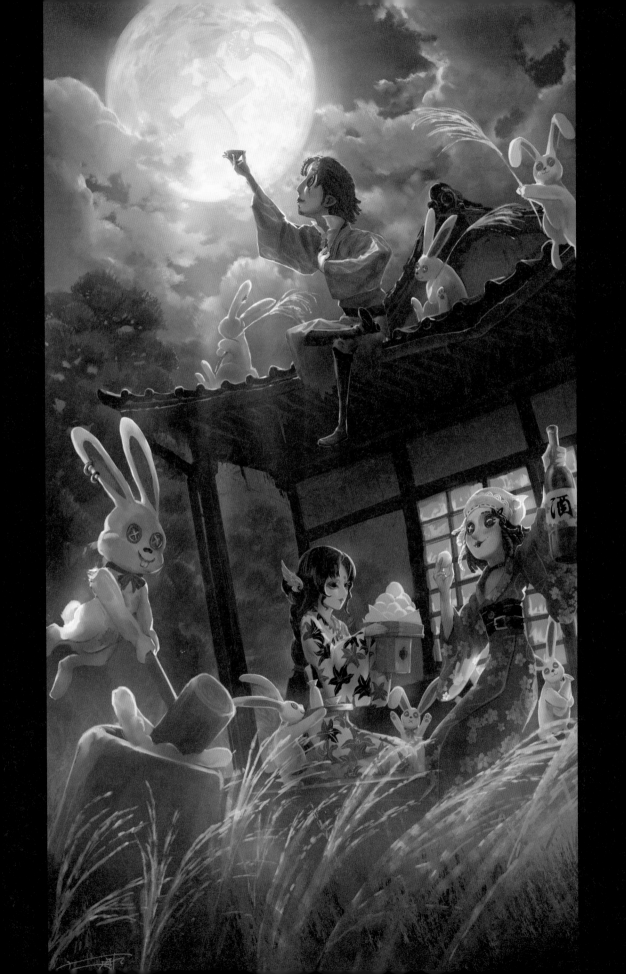

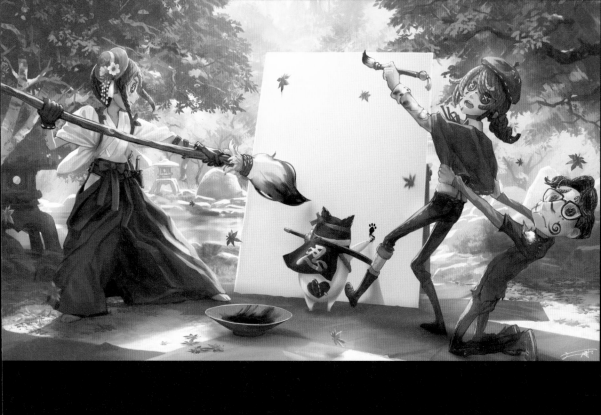

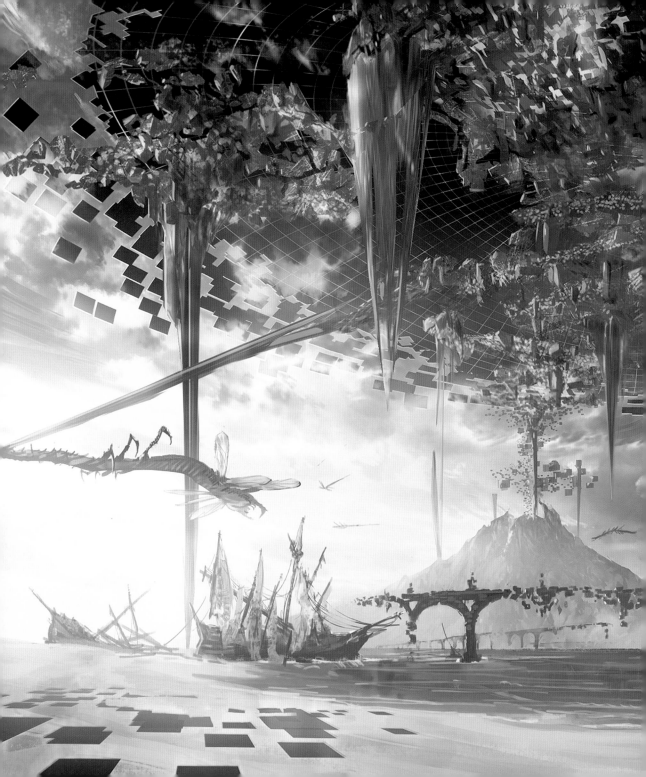

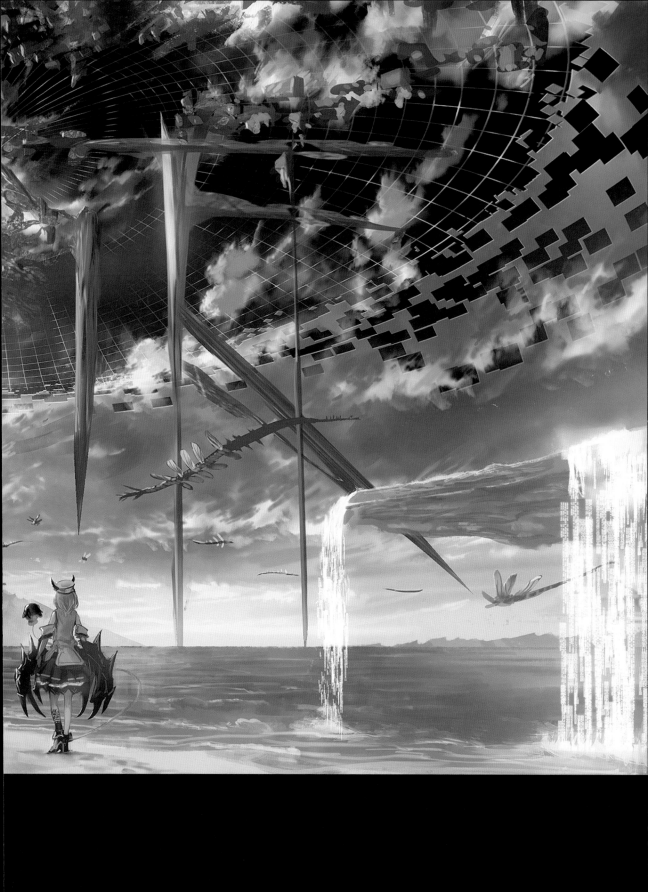

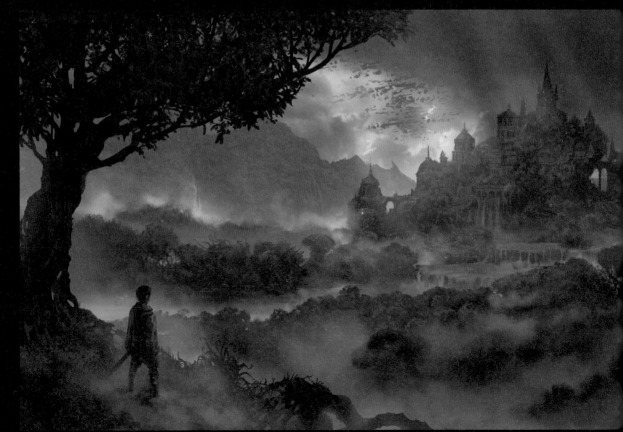

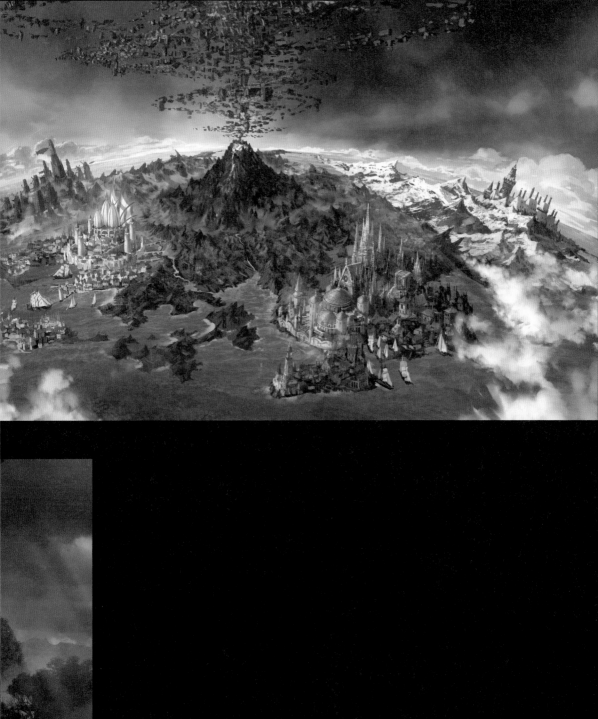

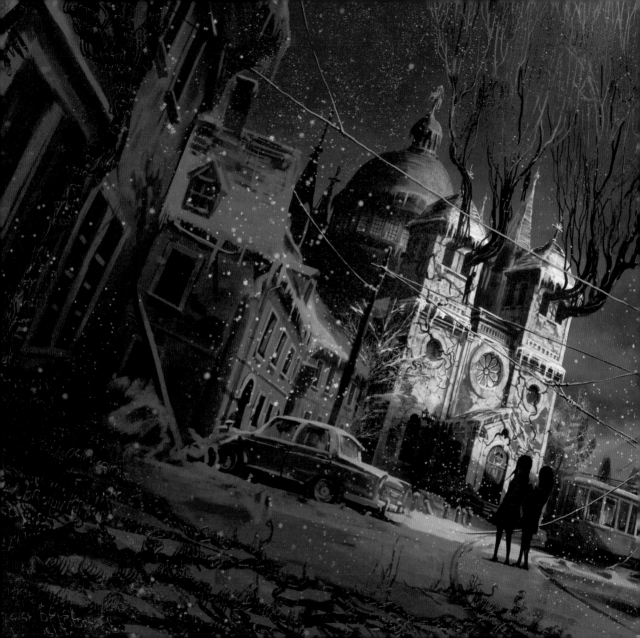

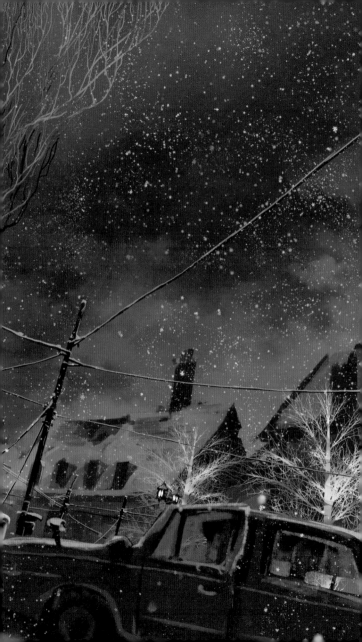

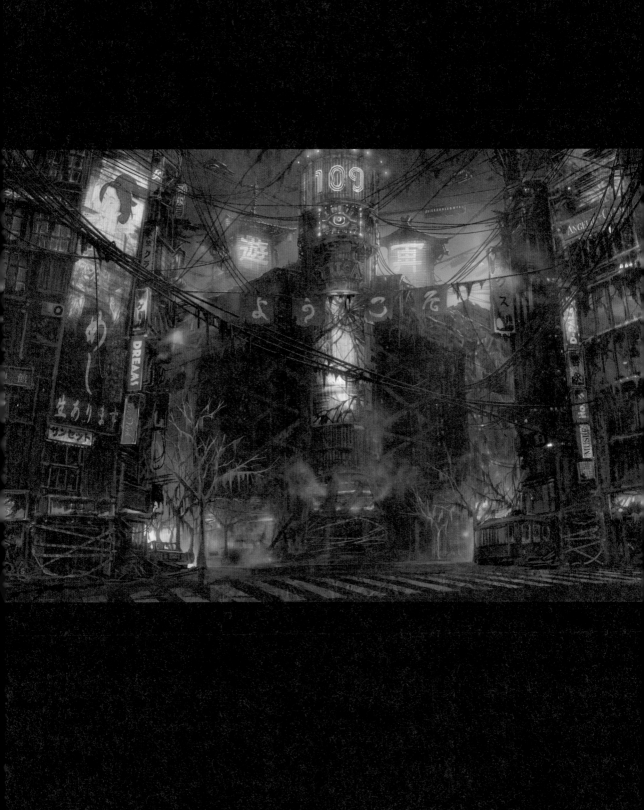

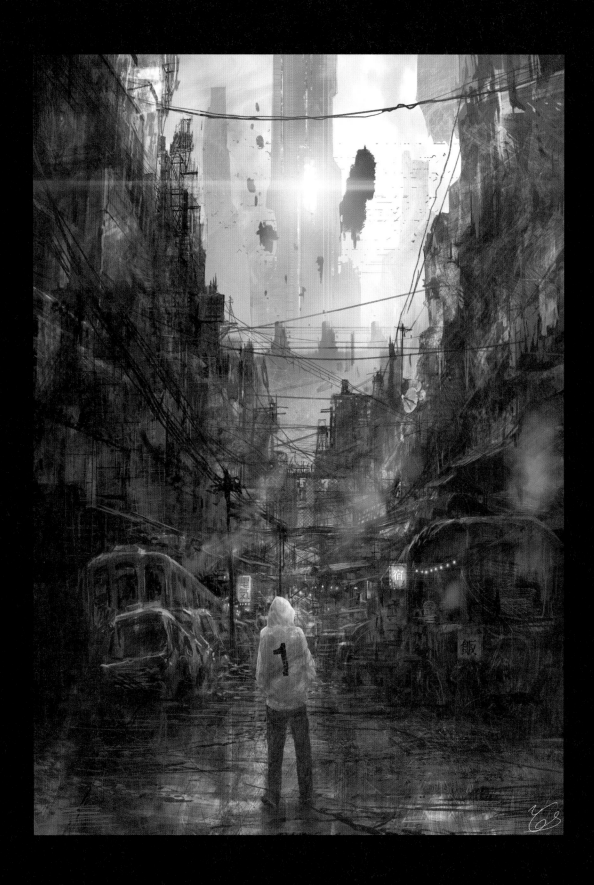

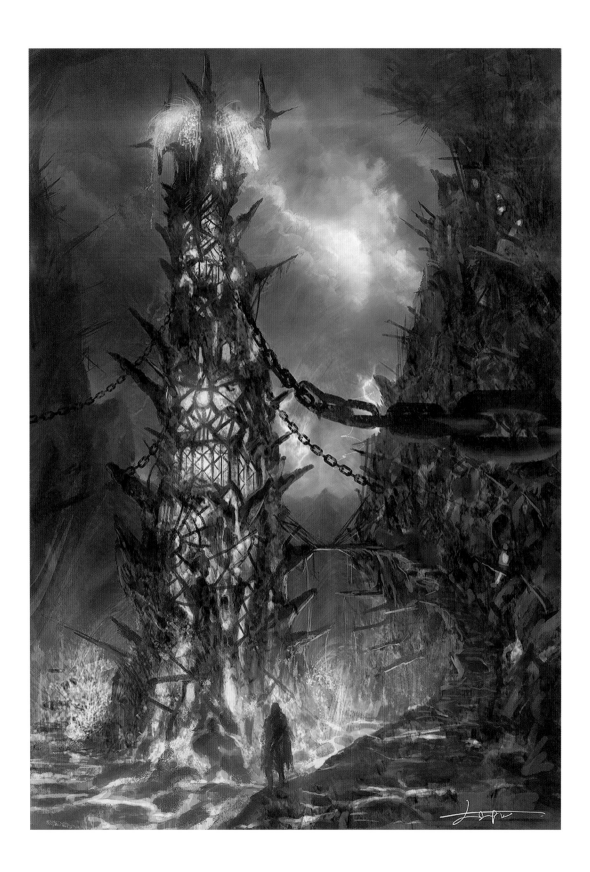

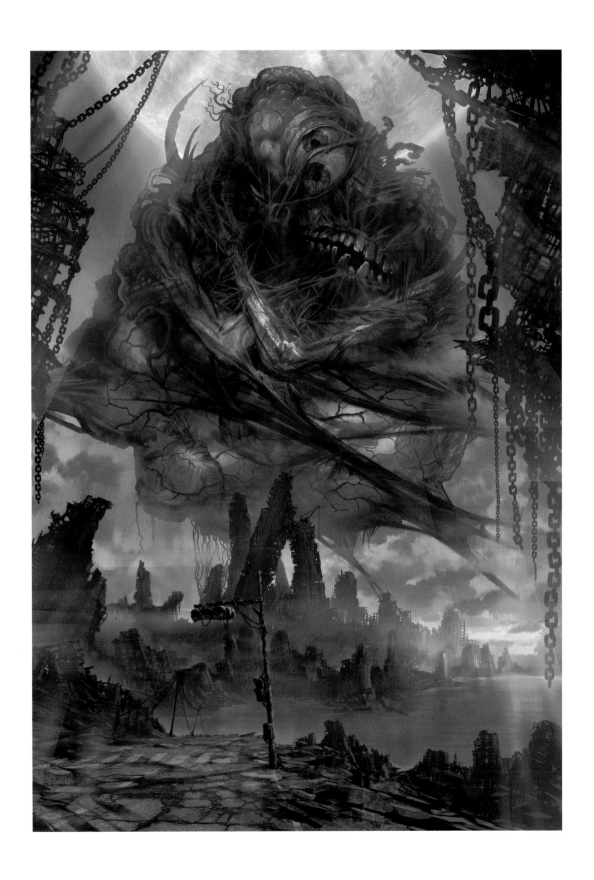

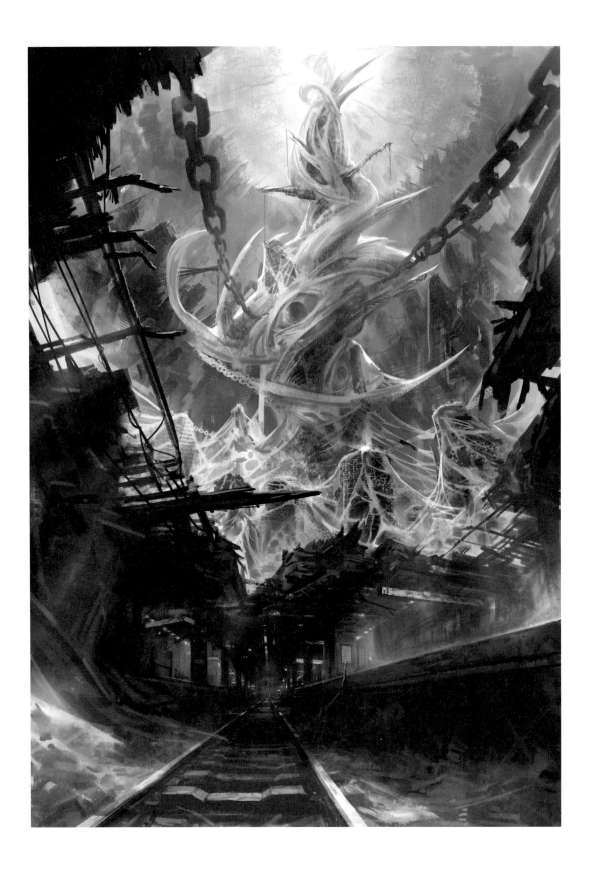

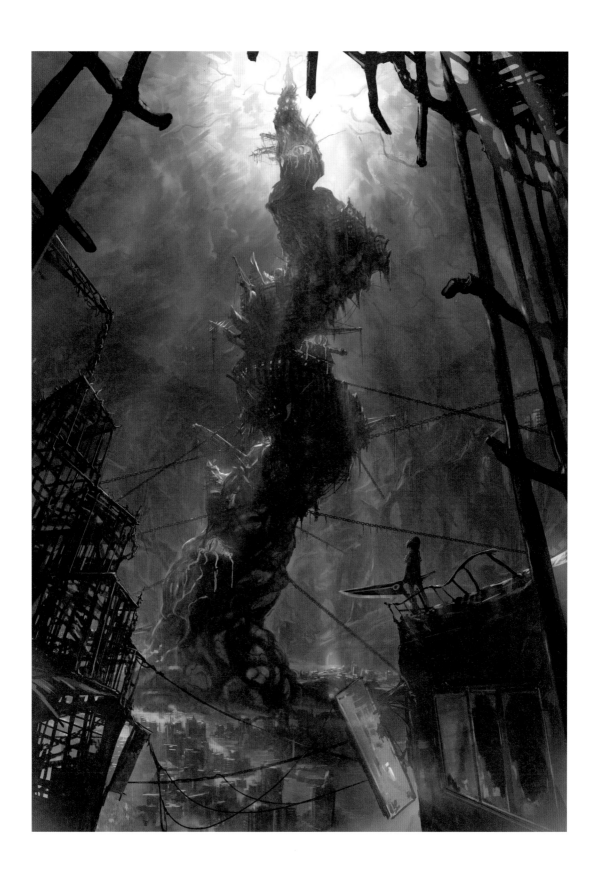

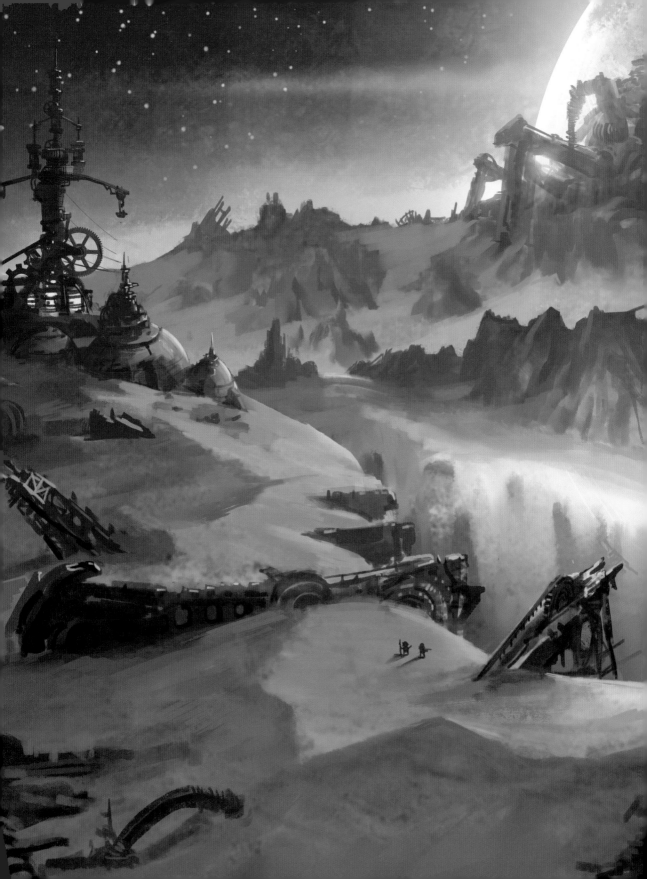

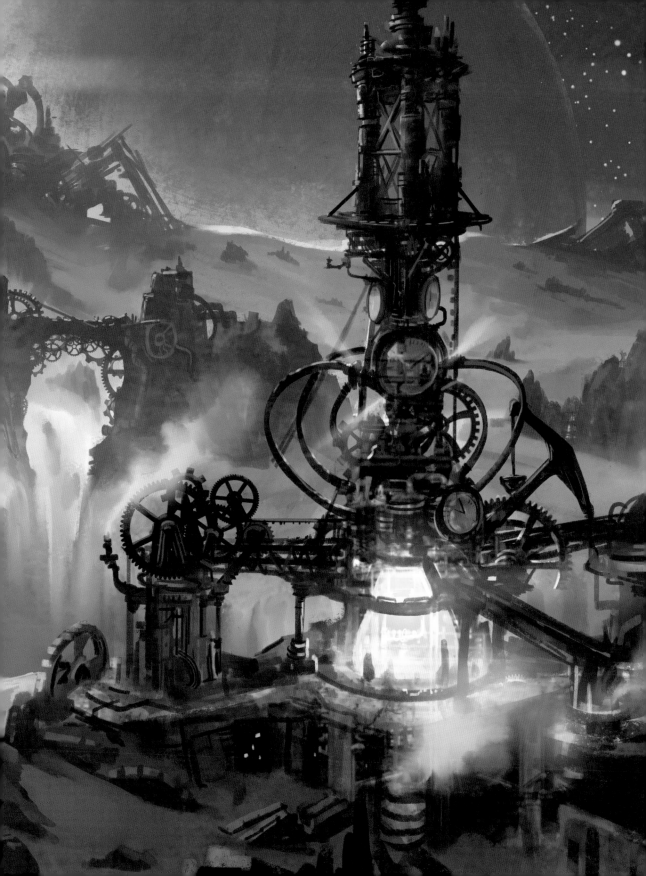

CONCEPT ART

本章ではアニメ『甲鉄城のカバネリ 海門決戦』や『Vivy -Fluorite Eye's Song-』などの作品で、実際に制作したコンセプトアートやデザインの一部を掲載しています。

Included in this chapter are parts of the concept art and design that were developed and produced for anime titles such as "KABANERI OF THE IRON FORTRESS – THE BATTLE OF UNATO" and "Vivy – Fluorite Eye's Song" among others.

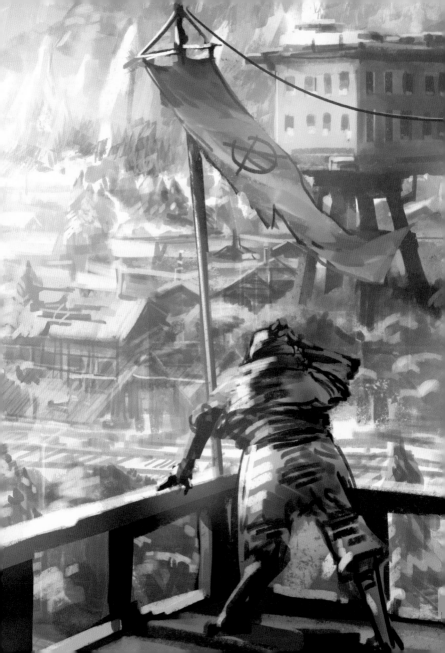

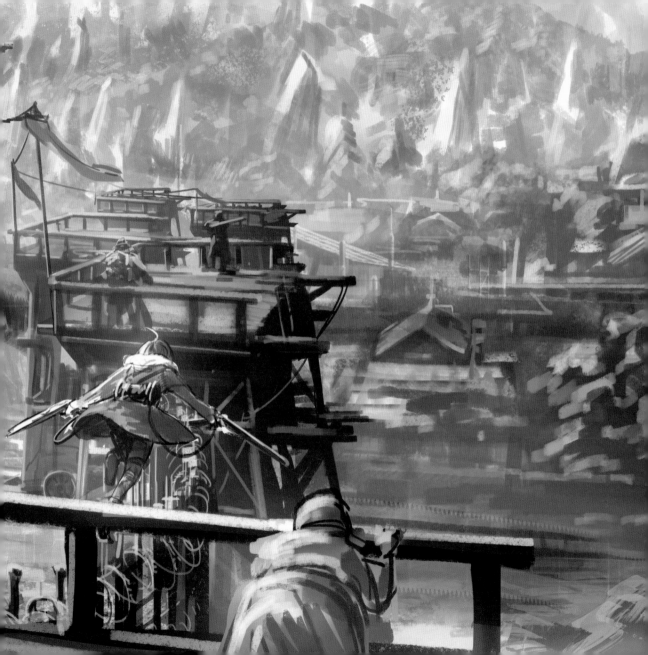

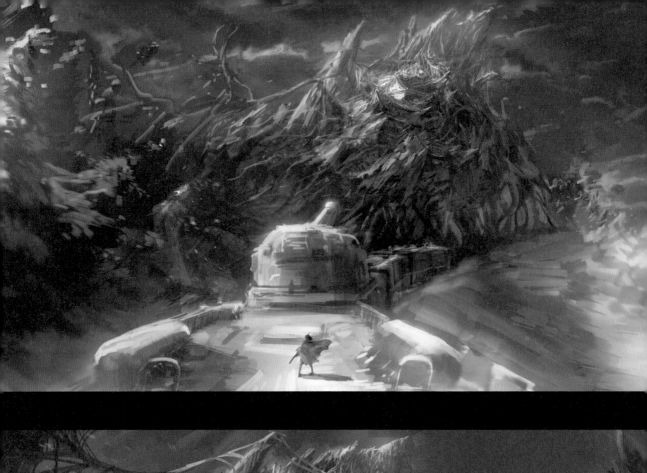
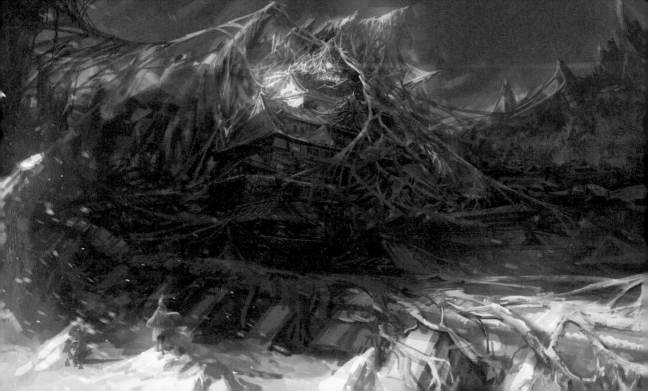

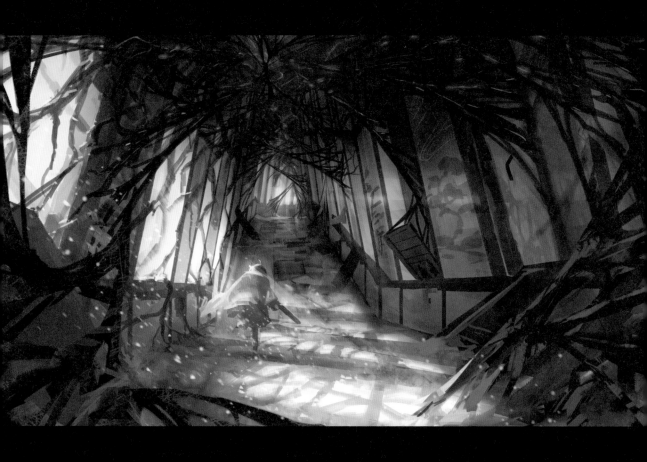

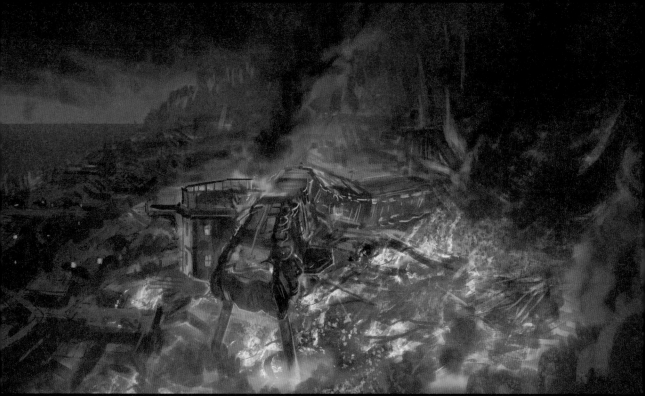

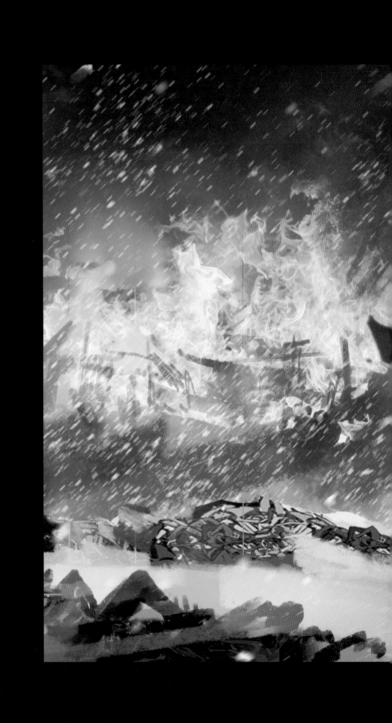

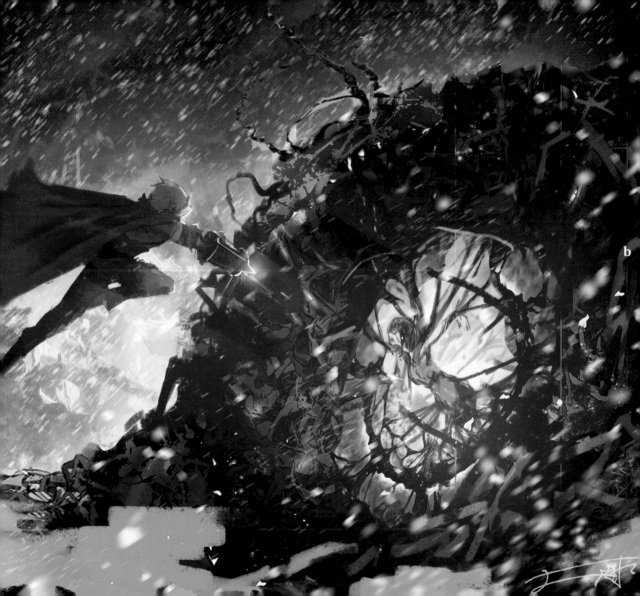

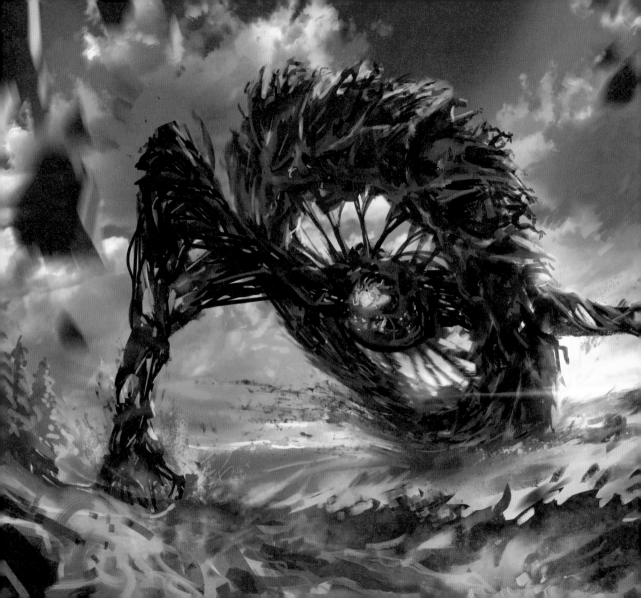

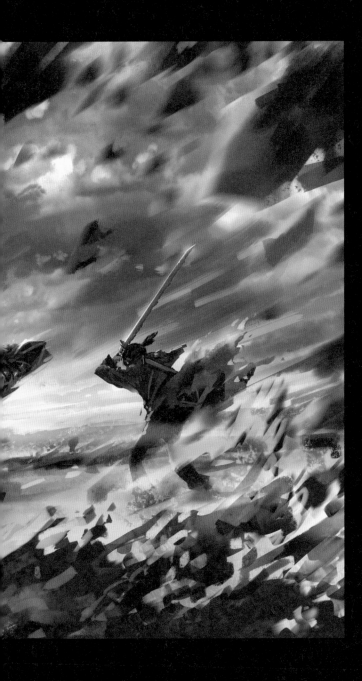

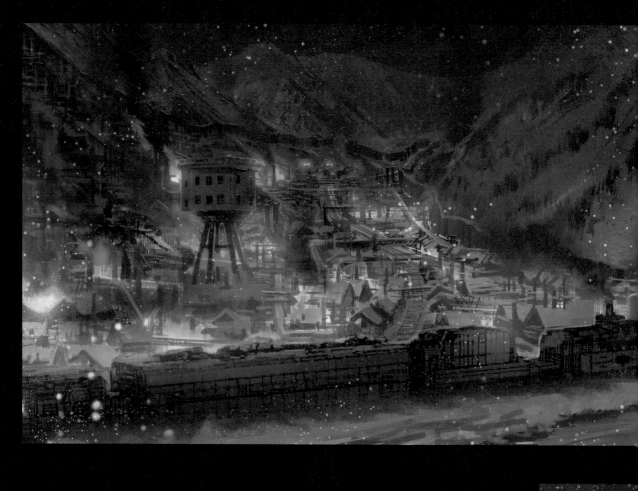

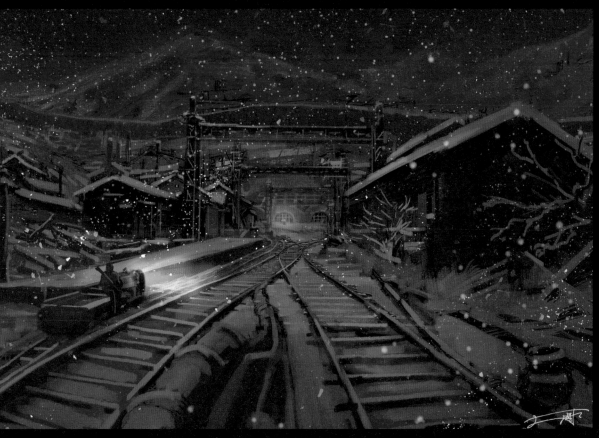

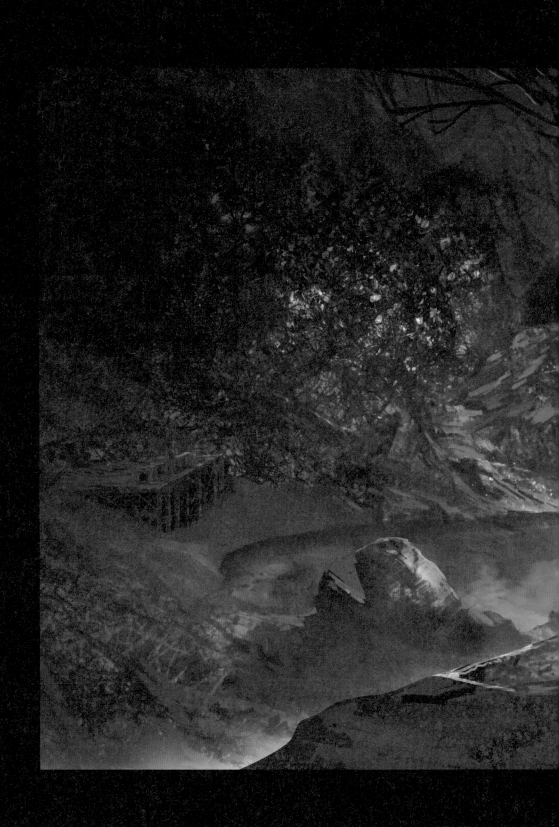

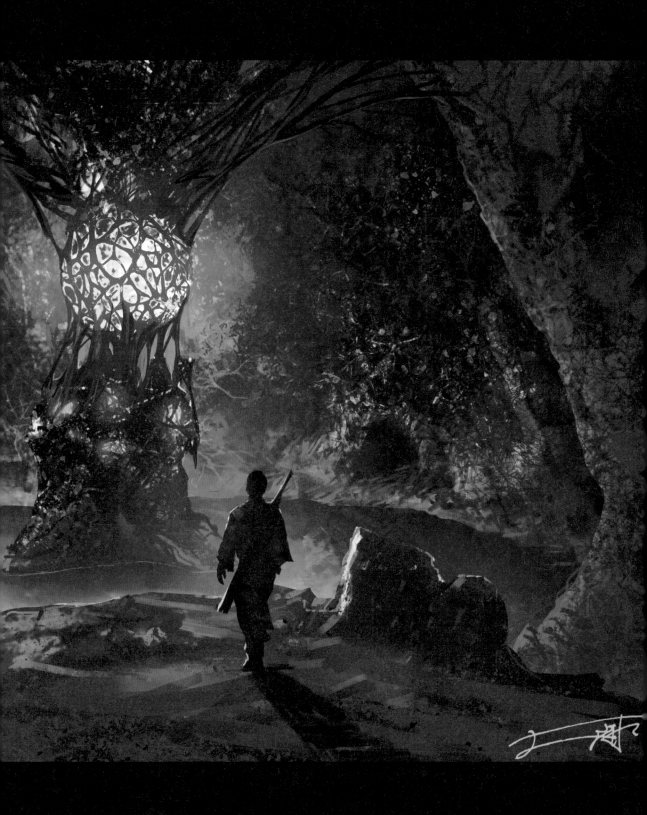

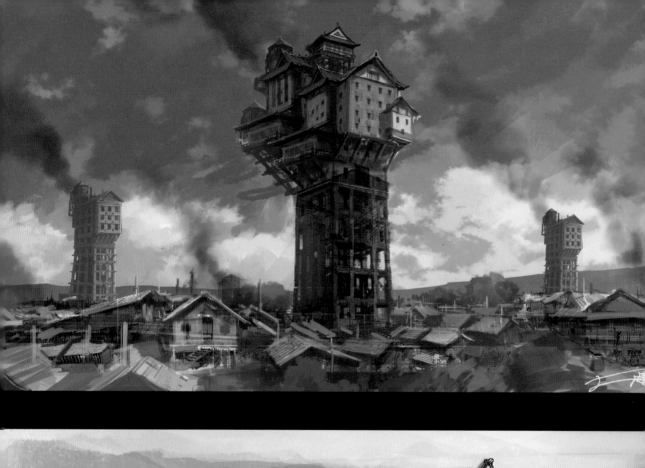
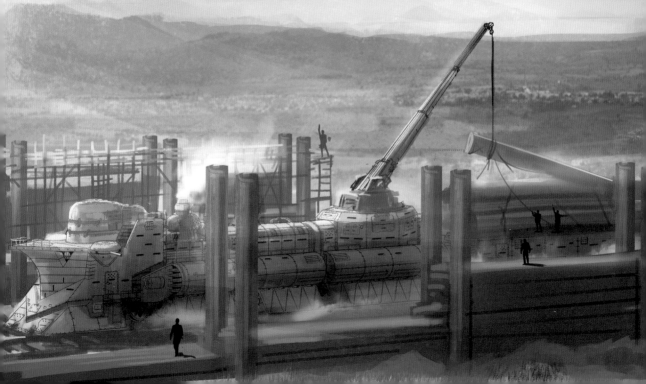

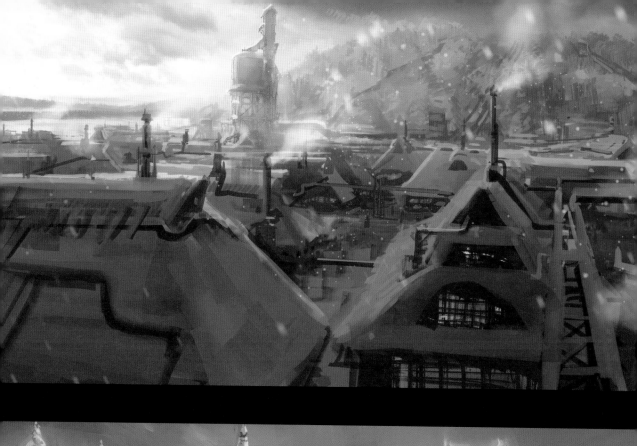
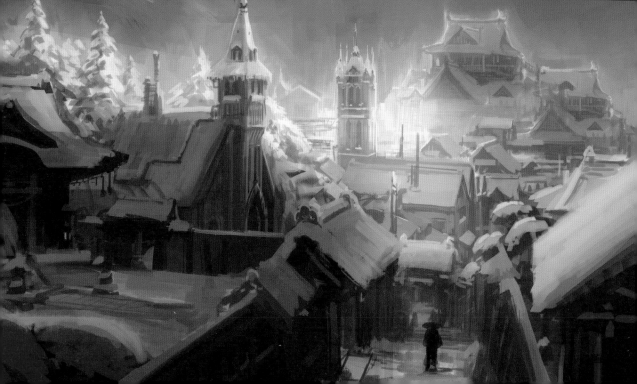

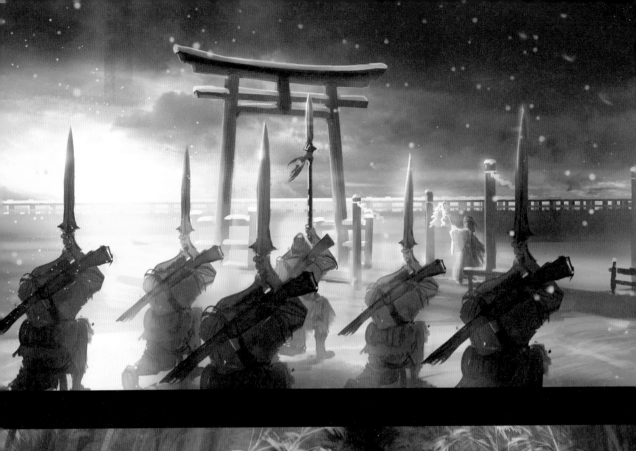
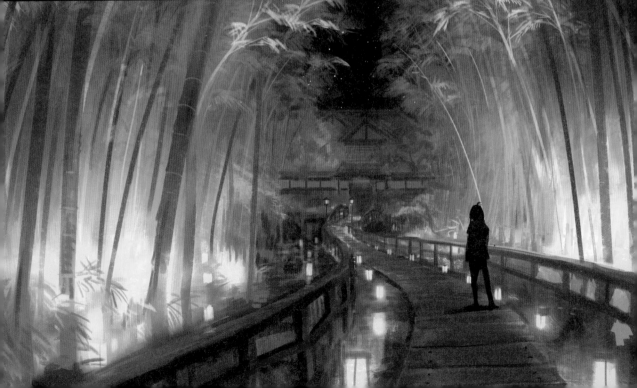

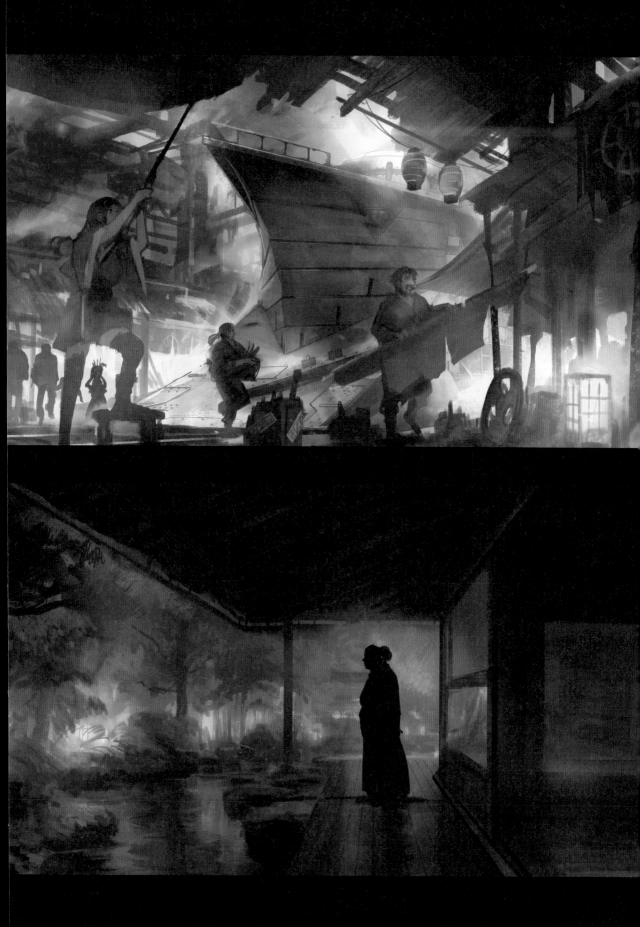

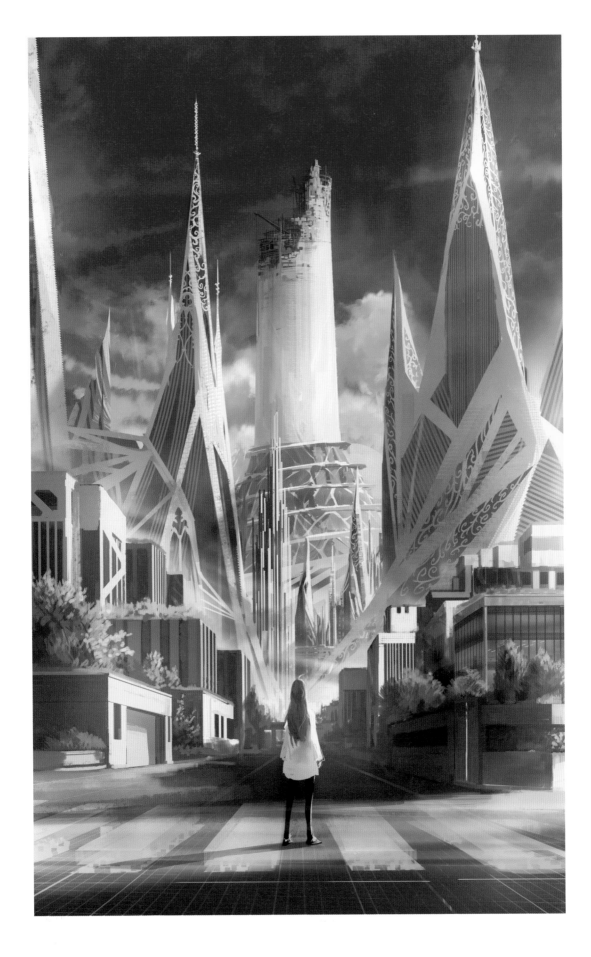

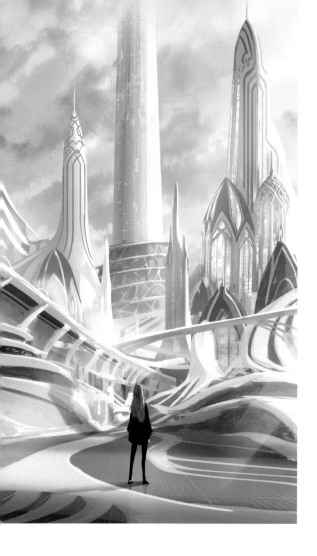

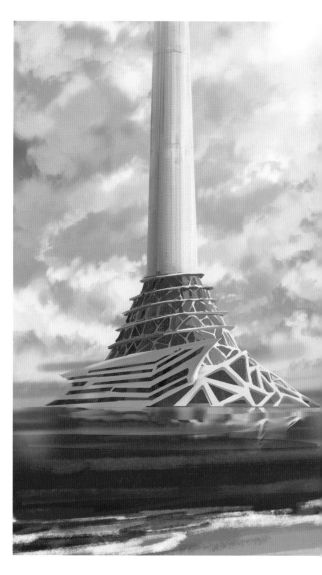

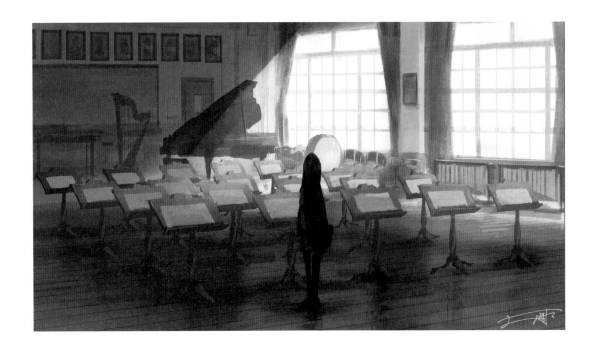

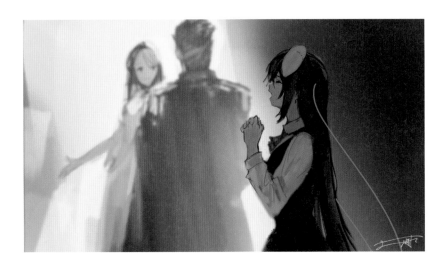

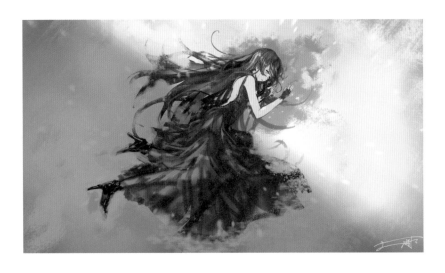

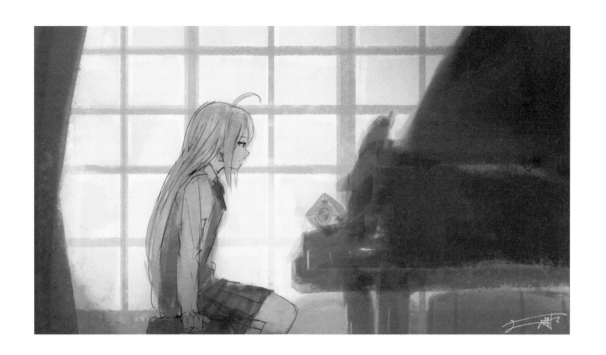

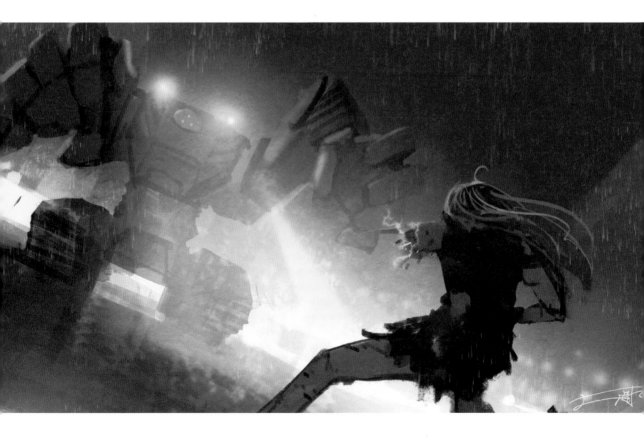

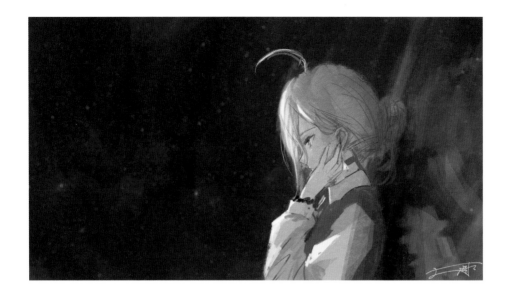

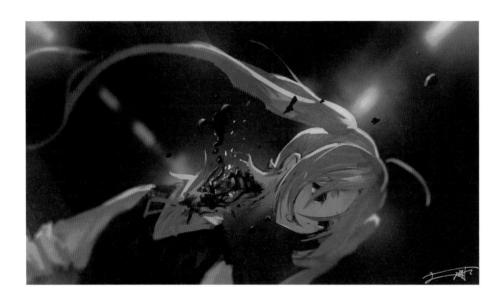

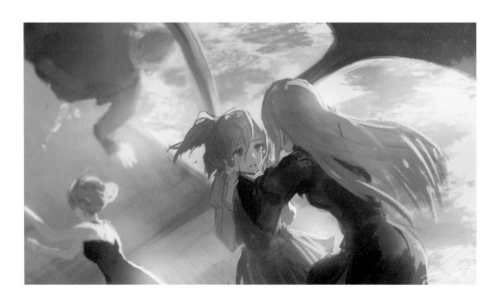

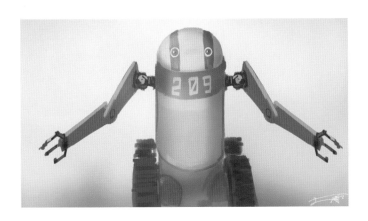

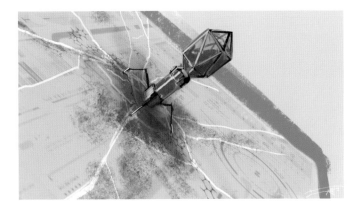

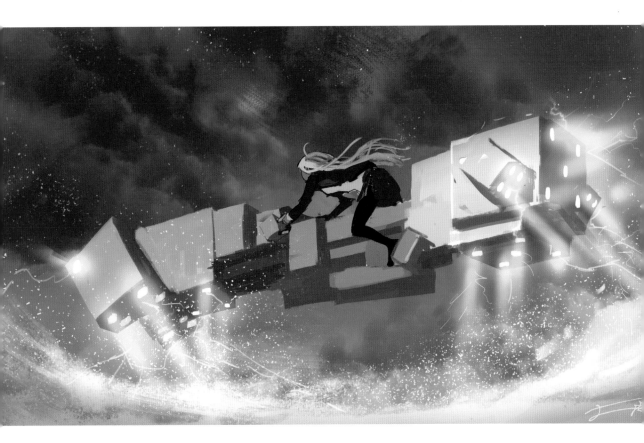

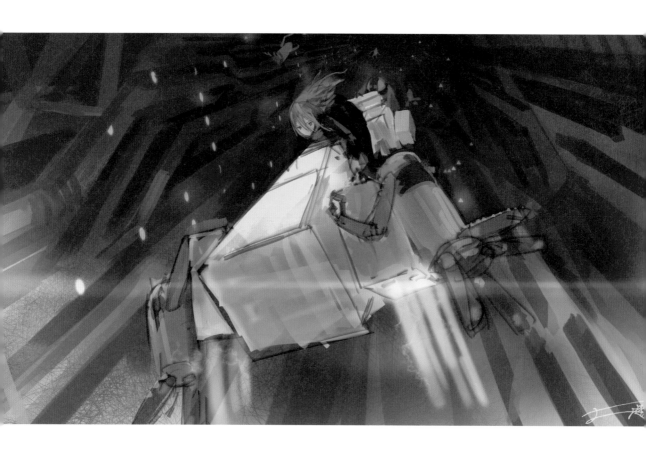

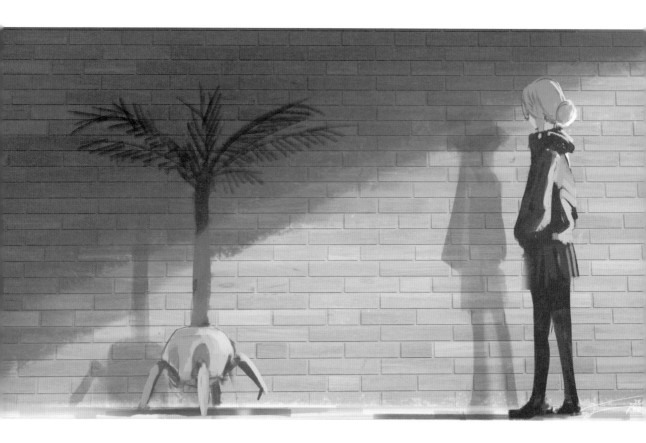

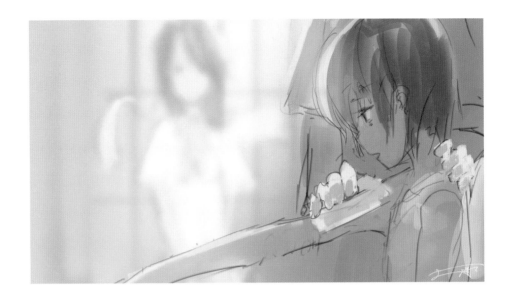

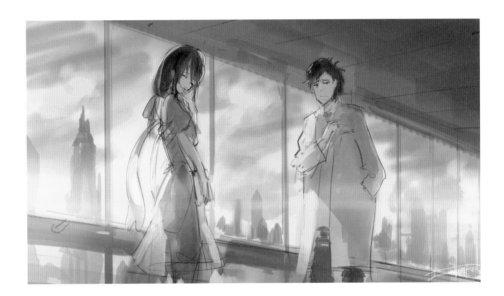

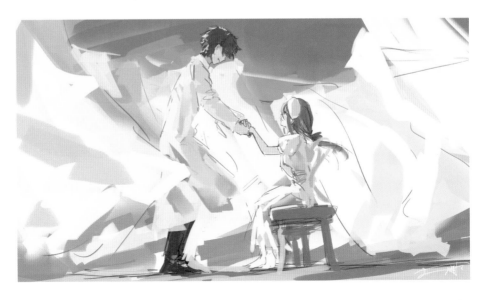

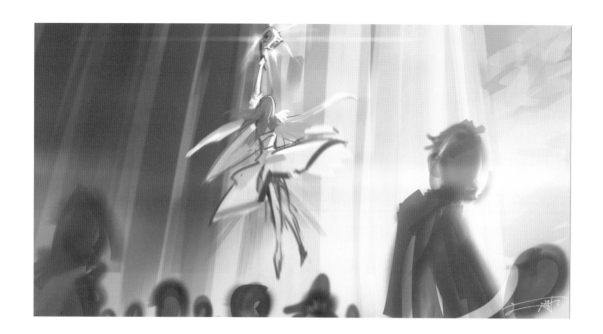

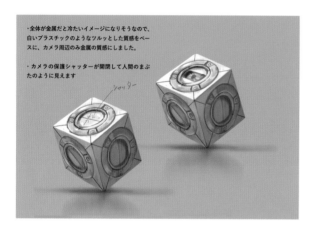

・全体が金属だと冷たいイメージになりそうなので、
白いプラスチックのようなツルッとした質感をベー
スに、カメラ周辺のみ金属の質感にしました。

・カメラの保護シャッターが開閉して人間のまぶ
たのように見えます

シャッター

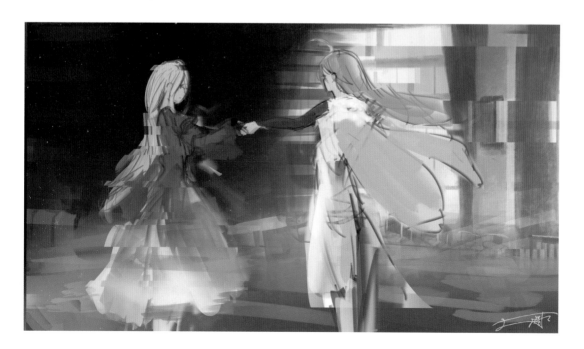

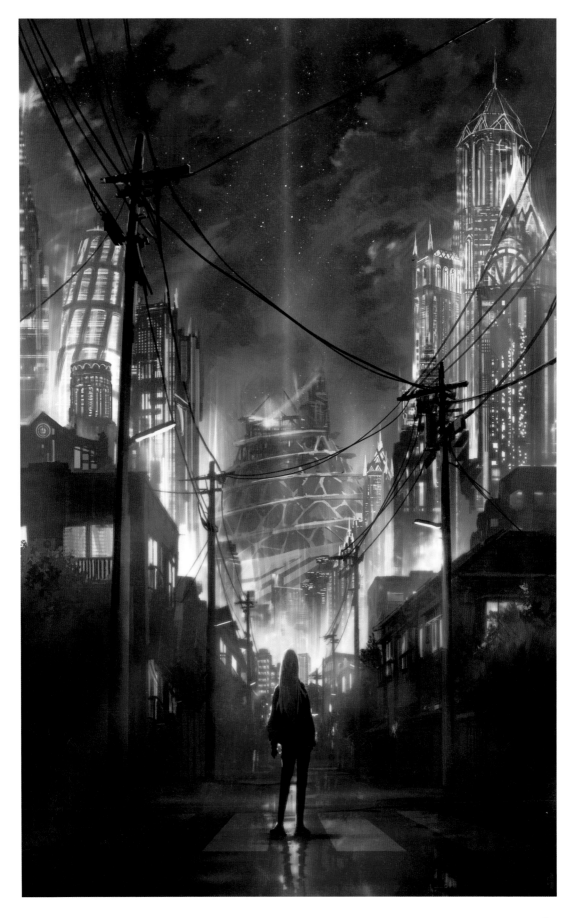

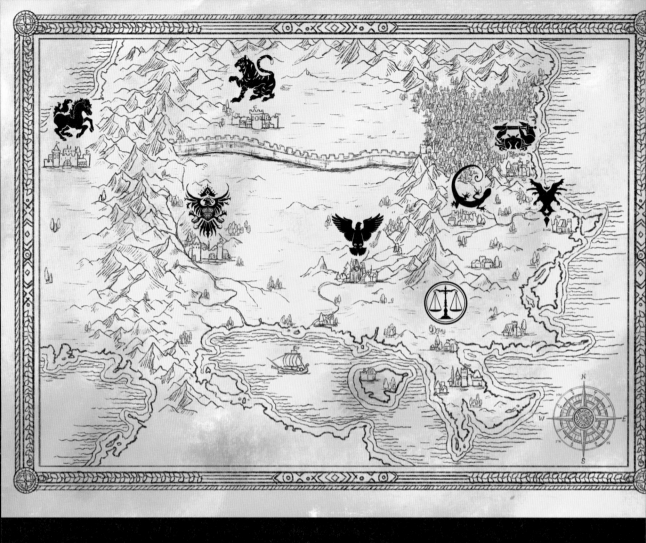

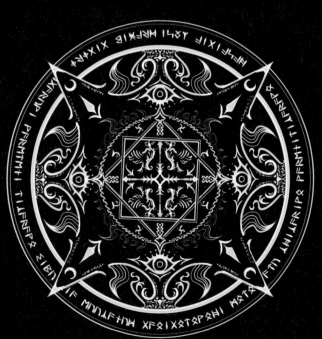

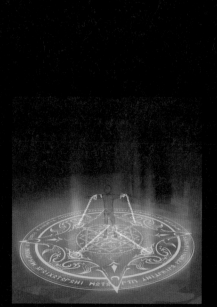

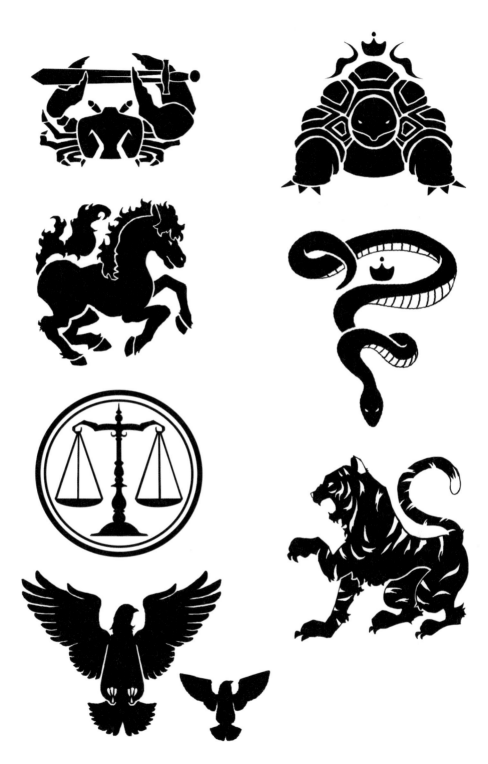

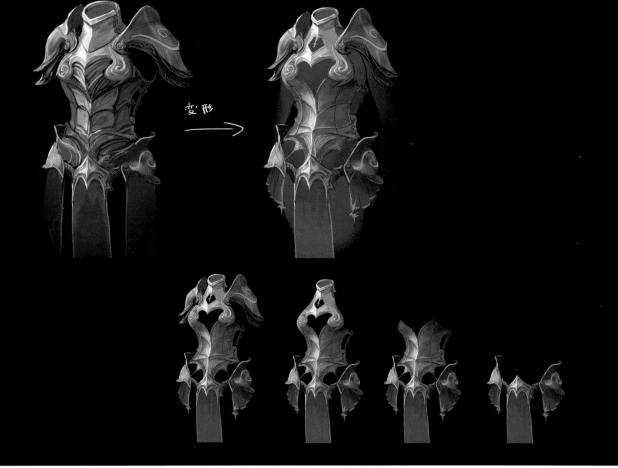

変形

フル装備

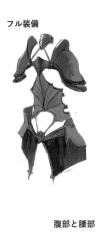

肩部なし

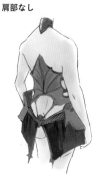

背面

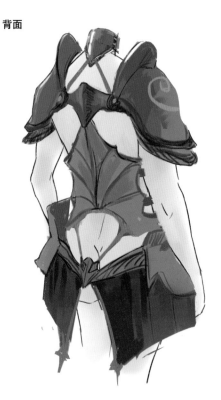

腹部と腰部

腰部のみ

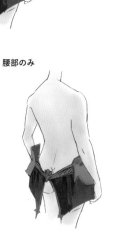

05

SKETCHING AND LINE DRAWING

スケッチと線画。私は大学生の頃にスタジオジブリの背景美術に憧れて、ほぼ毎日いろいろな場所で水彩スケッチをしていました。これらの練習で得た経験は、今も私の仕事を支えてくれています。

Sketching and line drawing. As a university student, I was fascinated by the background art in STUDIO GHIBLI works. I used to draw watercolor sketches wherever I was, more or less daily at the time, and the experience of that practice is still a supporting pillar of my work today.

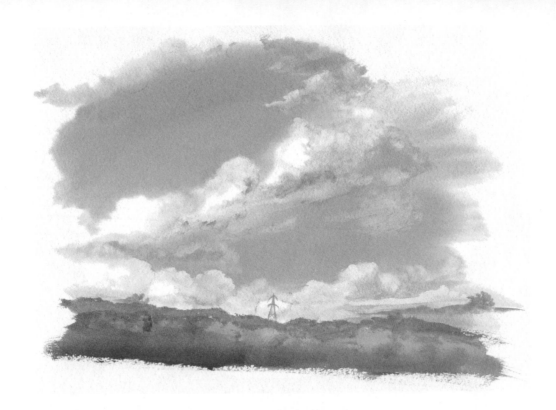

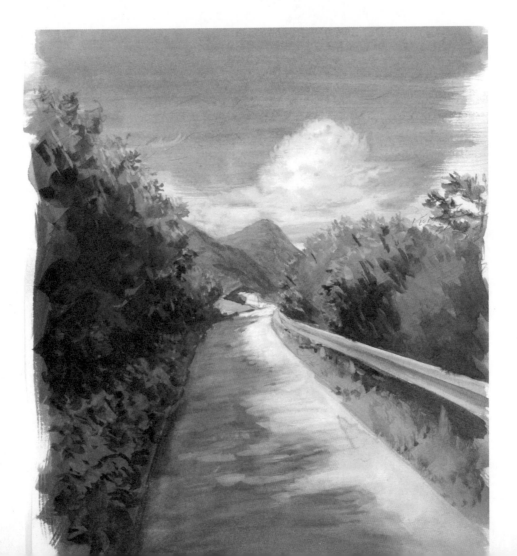

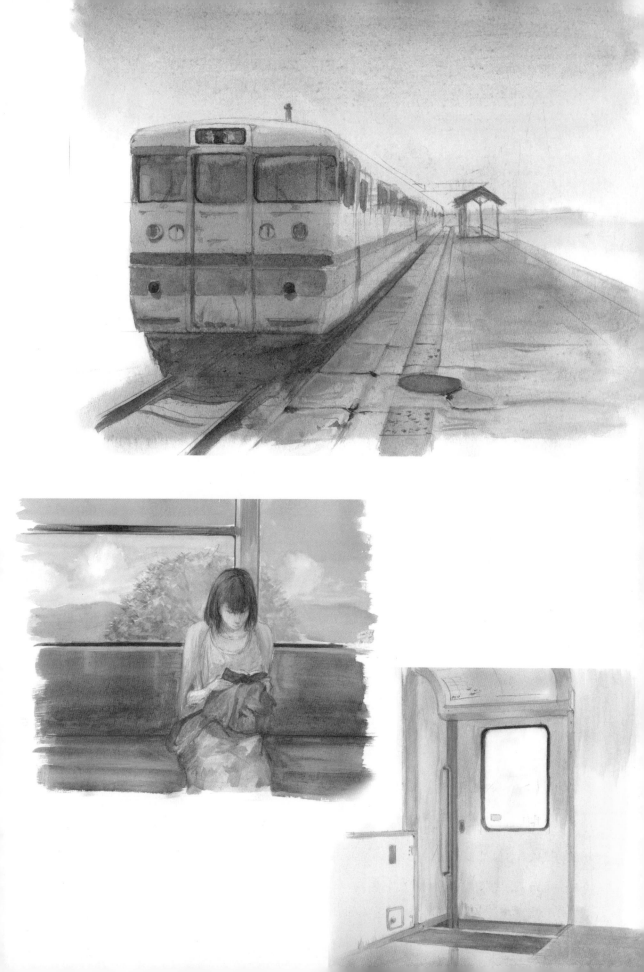

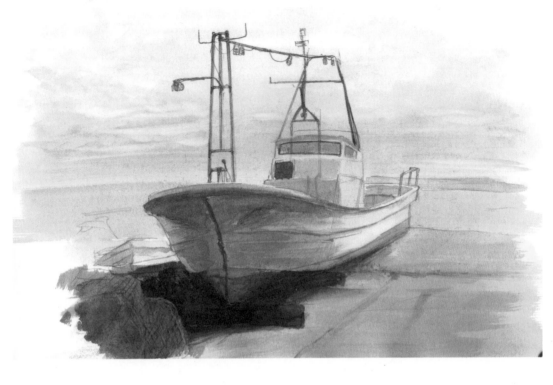

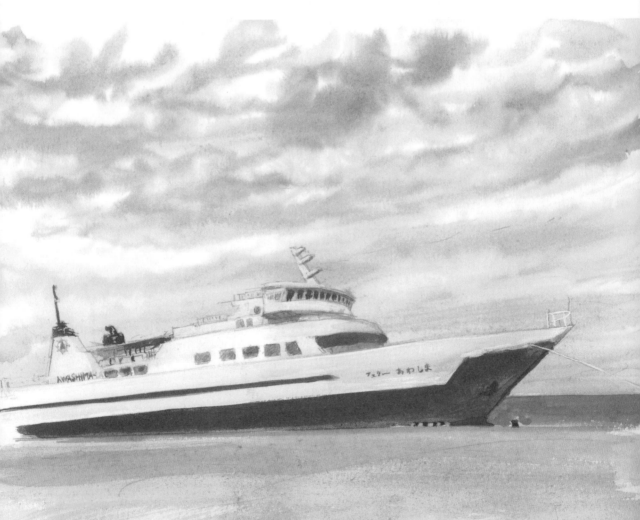

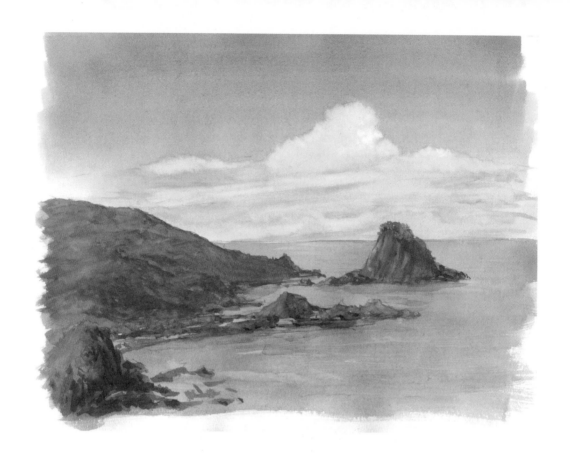

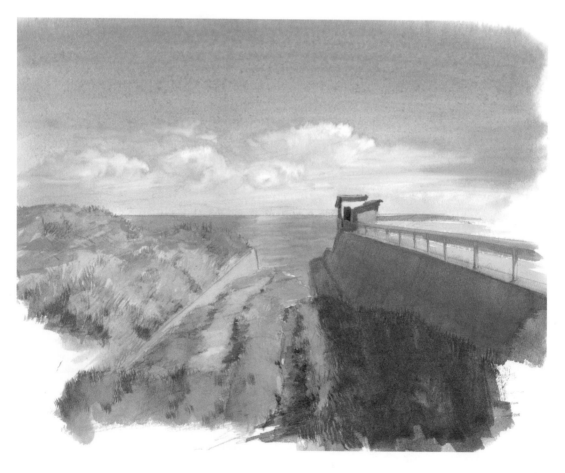

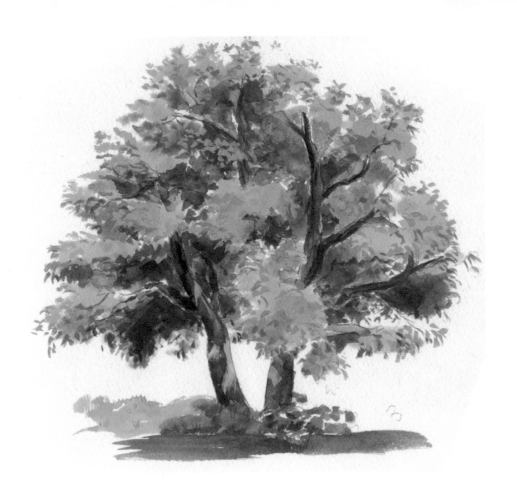

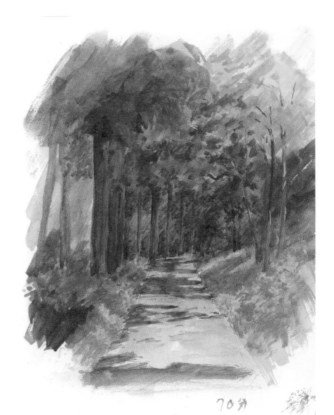

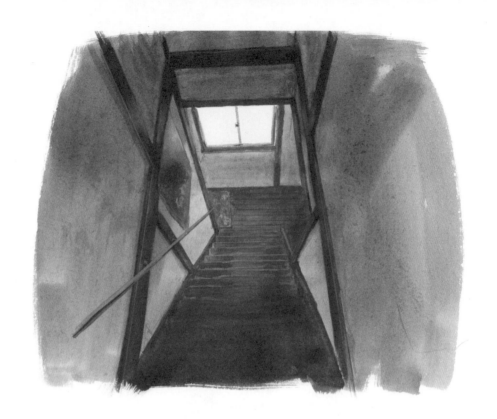

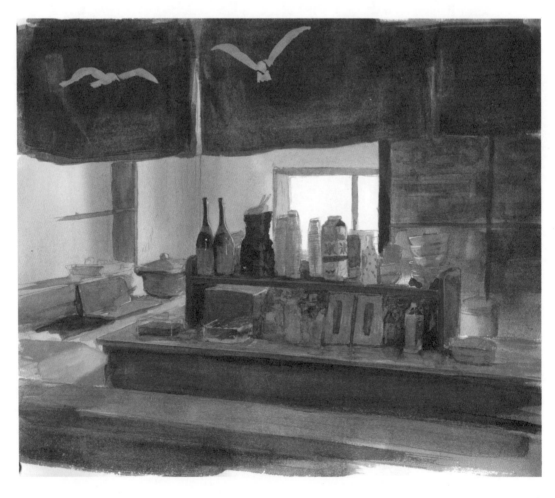

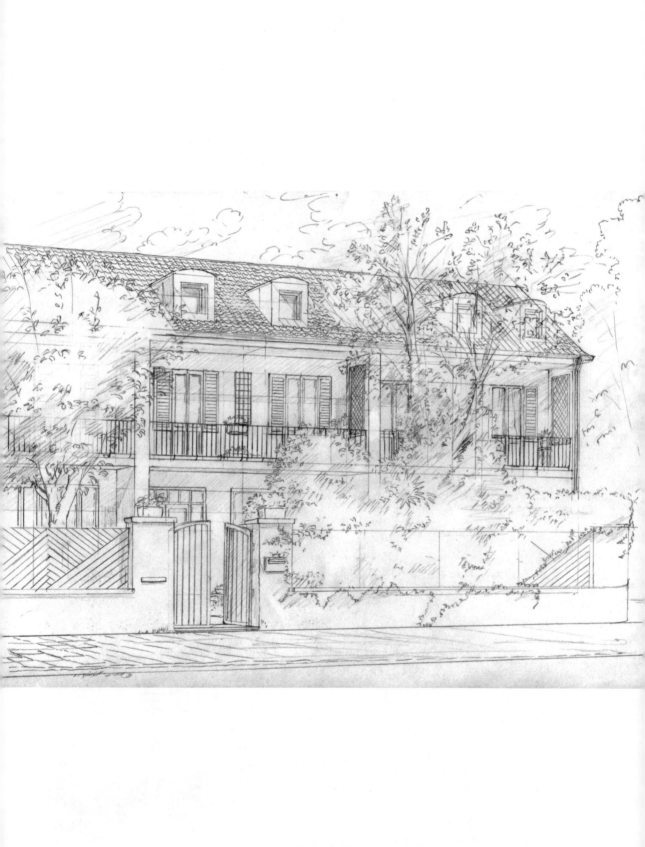

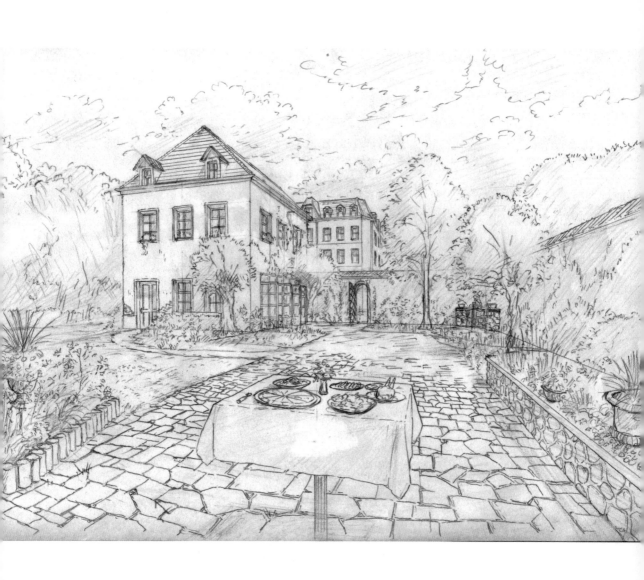

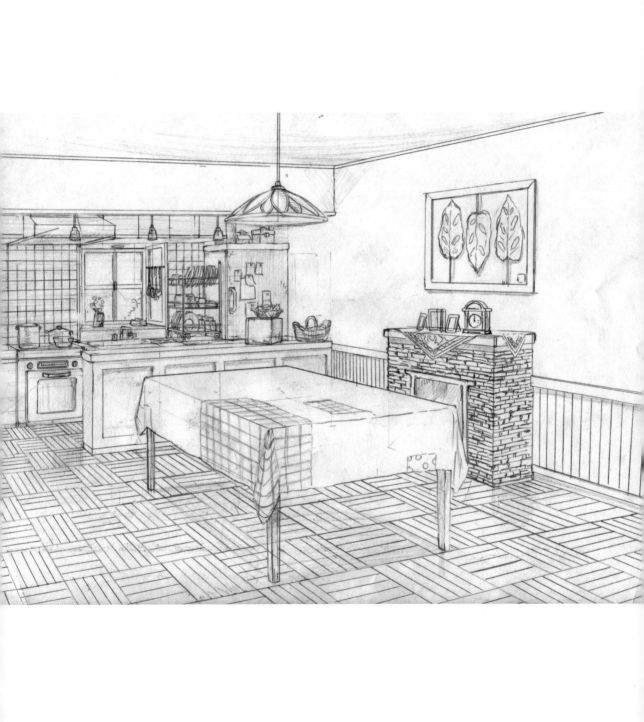

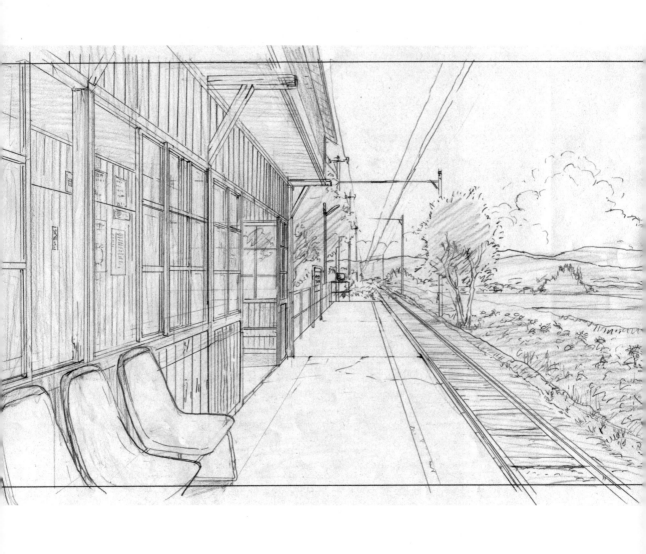

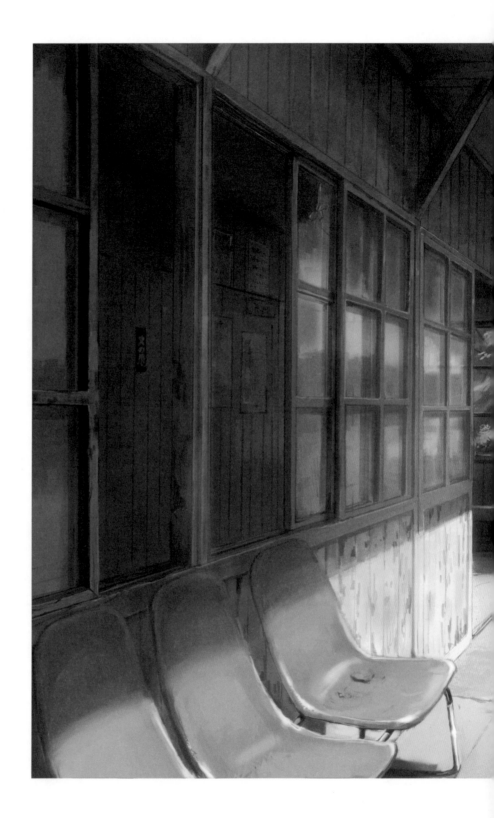

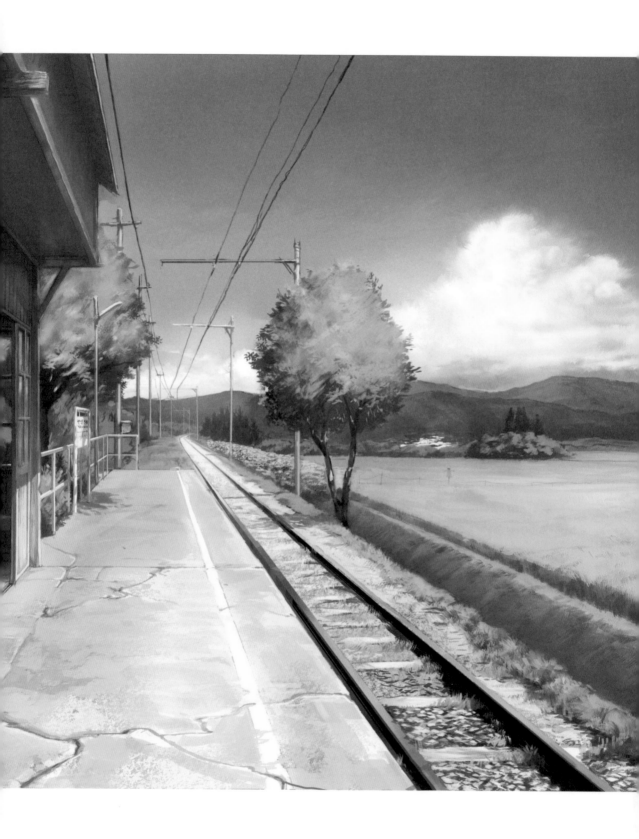

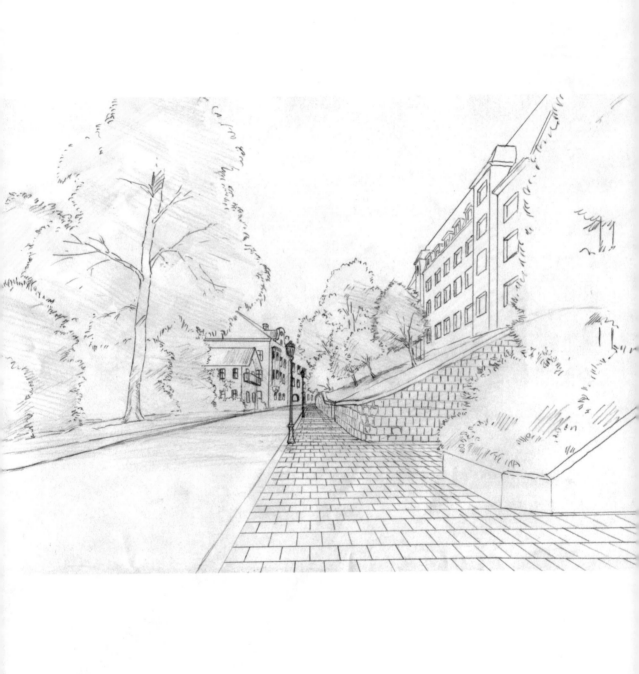

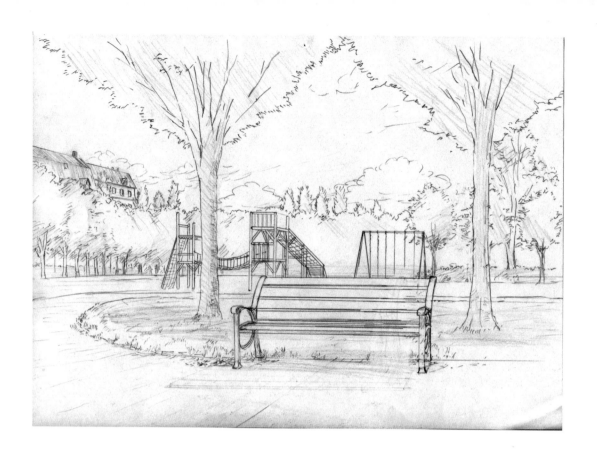

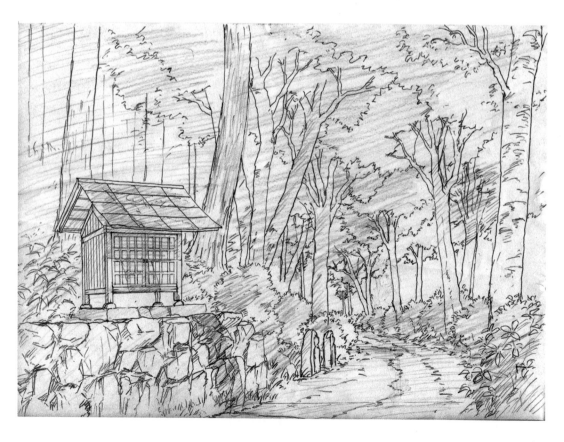

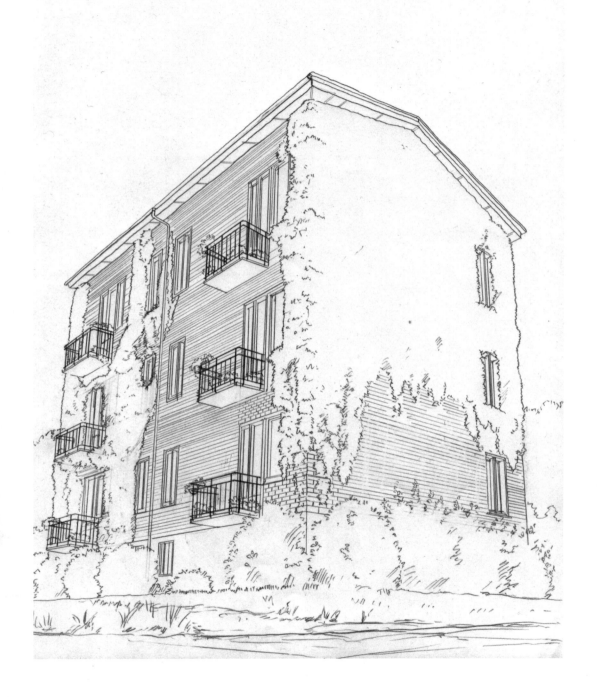

カバーイラストメイキング

Showcase of the Cover illustration process

❶

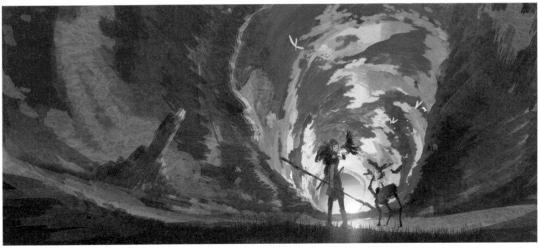

❷

まずは表紙としてふさわしいテーマを考えます。私のコンセプトアーティストという仕事は、作品の世界観をビジュアル化することが多いです。そのため、「世界を作っている、壮大」というテーマを設定しました。そこから世界を作るとはどういうことか考え、「スペースコロニー」というアイデアを思い浮かべました。壮大な印象にするためには3点透視図法が便利なので、パースグリッドを作成し❶、ラフスケッチを描きました❷。

First of all, I thought about a theme that would be appropriate for the cover. My work as a concept artist often involves visualizing the underlying "world concepts" behind the respective works, which inspired in me the idea of "creating worlds, depicting expansiveness" as a general theme. From there I thought about what it actually means to "create a world," and arrived at the concept of the Space Colony. Three-point perspective is the best technique when it comes to creating an impression of vastness, so I first made a perspective grid ❶, and then started drawing rough sketches ❷.

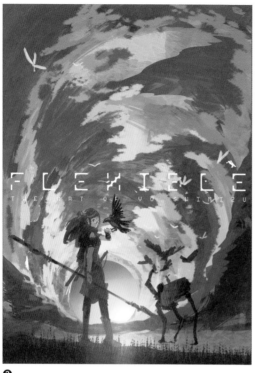

❸

当初は「スペースコロニー」案が気に入り、ある程度描き進めたものを提出し、ブックデザイナーに本書のタイトル「FLEXIBLE」のロゴ案を入れてもらいました。その上で改めて画集の表紙として見ると、見どころが少ないことが気になりました❸。画集はそれなりに大きなサイズの本として出版されるので、視線を強く惹きつける要素を強めに設定しないと、手に取ってもらいにくくなります。

そこで❹のようにスペースコロニーの支柱を描いたり、別の要素を追加したり、試行錯誤を重ねました。しかし、どの案もしっくりきません。煮詰まってしまったので、妻に絵の感想をもらうことにしました。妻は「スペースコロニーを知っている人は少ないのでは？」と言いました。なるほど、確かにその通りだと思いました。私はSFが大好きなので、円筒形を回転させて遠心力で疑似重力を作り、その中に人工居住地を作るスペースコロニーというものを知っていましたが、世間では知っている人はそれほど多くなく、テーマが伝わりにくいことに気づきました。
映像やゲームであればアニメーションで動かすことができますが、表紙は一枚の絵で全てを伝え切る必要があります。表紙としてしっくりこない原因はここにありました。

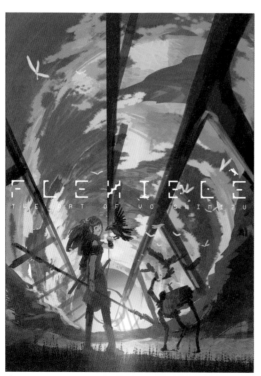

❹

I liked the Space Colony idea, so I went ahead drawing sketches. At some point, I passed one of them to the designer, who got back to me with a number of logo suggestions for the book's title, "FLEXIBLE." Once I looked at the cover with the title on it, I realized that it was rather unspectacular as a representation of my work ❸. As the book would be made in an accordingly large format, I realized that, in order to inspire people to pick it up, the cover needs to be eye-catching, so I decided to include more elements to enhance the visual impact.

I tried and added things like supporting pillars of the Space Colony ❹ and other elements, but no matter what I did, it just didn't feel right. So I decided to ask my wife what she thinks, and her response was, "Maybe there aren't many people who are familiar with the Space Colony concept in the first place." She was absolutely right. As a science-fiction fan, I knew about the idea to build an artificial human colony in a rotating cylinder, with "gravity" generated through centrifugal force. But as my wife pointed out, most people are certainly not, so they would probably not understand what the cover was all about. With video or animation, you can move things around to get your idea across, but in the case of a book, you only have the cover art to communicate everything. The picture I had drawn failed to do so, and this was exactly why it didn't feel right.

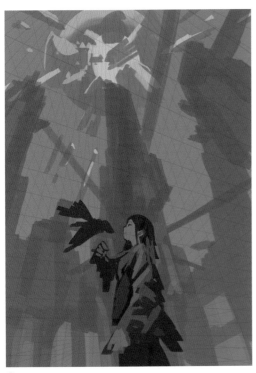

経験上、最初にしっくりこない作品をいくら丁寧に仕上げても良いものになることはあまりないので、思い切ってこれまでのアイデアを捨てます。今までのラフを捨てることはもったいないかもしれませんが、本当に良いものを作ろうとするときは失敗することも大切です。
もう一度最初のテーマに戻って考えてみます。
そこで思いついたのが「星を作るもの」というアイデアです。遥か遠くの銀河では星自体を０から作る超文明があるかもしれません。

新しいラフを描き始めます。3点透視図法のパースグリッドはそのままに、パースに沿って高いビルを描き、ビルを目で追っていくと空の向こうに建設中の星があるという構成です。キャラクターが欲しいので、手前に女性を描きましたが、この時点ではストーリーは特に決まっていませんでした❺。

表紙となる部分を横に伸ばし、裏表紙の構成も考えて、最終的に❻のようになりました。

❺

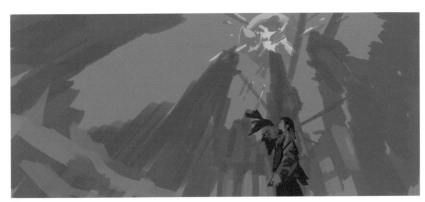

❻

Based on my experience, if the first attempt doesn't feel right, it probably never will no matter how hard you keep working on it. Trashing all the ideas and sketches made in the process may seem like a waste, but I'm aware that it is necessary, and failure is one important step on the way to creating something really good.
So I returned to the basic theme and started thinking all over again.
The next idea I came up with was "the creation of a planet." Somewhere out there in a faraway galaxy, there may exist some kind of super-intelligence that builds planets from scratch.

I started drawing new sketches, reusing the three-point perspective grid, along which I drew tall buildings this time. The idea was that the buildings would point toward a place in the sky where a new planet was being created. I thought there should be some kind of human figure, so I added a female character in the foreground, however at this point I was yet to build a narrative around it ❺.

I horizontally expanded the part that would be used for the cover, to work out and finalize the composition ❻.

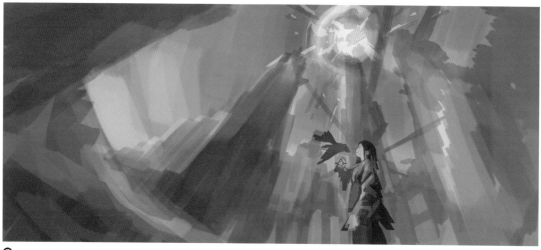

❼

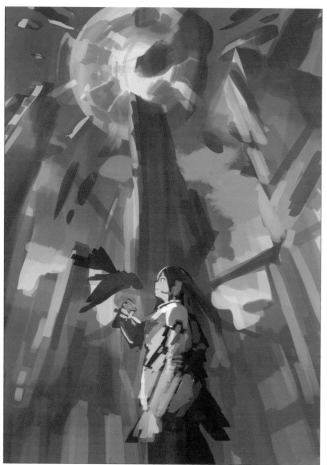

❽

「オーバーレイ」レイヤーを作成し、下塗りをします。ライティングは左の丘の向こうから右の女性に向かって光が当たるようにイメージしました❼。

ある程度、色がついたらレイヤーを全て統合し、光が当たっている左側を中心にタッチを入れてぼんやりした絵を徐々にはっきりさせていきます❽。はじめ、女性の服は民族衣装のようなデザインでしたが、ハイテク装備に変更しました。といっても、まだストーリーははっきりしません。この女性は一体何者なのでしょうか。

I started by creating a new layer, and then made the undercoating using the "overlay" mode. For lighting conditions, the idea was to have the character on the right illuminated by a ray of light coming from behind the hills on the left ❼.

Once I had enough colors to work with, I merged all layers together, and added finishing touches especially to the left, illuminated part. The initially vague picture gradually took on contours ❽. I initially dressed the character in something that looked like a folk costume of sorts, but I replaced that with a rather high-tech kind of outfit. Anyway, the narrative was not clear yet, so I still needed to work out who or what exactly that character was supposed to be.

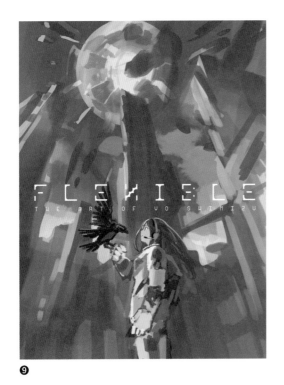

女性の装備をデザインしていきます。全体的に落ち着いた雰囲気になりそうなので、装備の色はビビッドな色で目を引くようにしました❾。

そんな中でやっとストーリーを思いつきました。「汚染された地球から脱出した人類は、地球の環境を元に戻すため、AIに全てを任せた。数世紀ぶりに帰ってきた人類が見たのは緑に覆われた地球と、進歩したAIが作るもう一つの地球」というものです。女性は帰ってきた人類の調査員で、緑に覆われた地球ともう一つの星を見ているシーンです。女性が従えているのは鳥型の調査ドローンで、女性も鳥の羽のような飛行ユニットを装備しています❿。なぜ鳥にしたかというと、私のアバターが鳥だからです。

「AIが環境を復元する」「鳥型のドローン」というアイデアは私の大好きなPS4のゲーム『Horizon Zero Dawn』に、AIが進歩して超文明になるという発想はレイ・カーツワイル氏の著書『シンギュラリティは近い 人類が生命を超越するとき』に影響されています。

❾

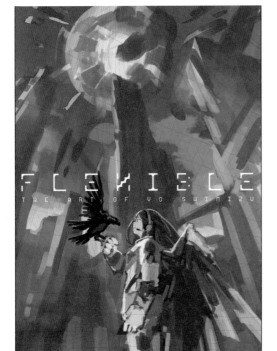

❿

I designed the female character's costume. Given that the image as a whole was likely to be dominated by a rather calm mood, I chose vivid colors for the character's outfit in order to make it stand out visually ❾.

At the same time, the narrative finally took shape. "Humankind, after escaping from the contaminated planet Earth, relies on artificial intelligence in order to restore the Earth's original environment. Several centuries later, a human returning to the Earth finds the planet covered with plants, while another, new Earth is created by advanced AI."
The character is a human investigator, who returns to the overgrown Earth, and from there witnesses the birth of the new one. She is accompanied by a bird-shaped examination drone, and the investigator herself wears some kind of flying gear in the form of a bird's wings on her back ❿. I chose the bird format because my own avatar is a bird.

Some of the ideas, such as "artificial intelligence restoring the Earth's environment" or the "bird-shaped drone," I drew from my favorite PS4 game, "Horizon Zero Dawn," while the concept of an "artificial super-intelligence" was inspired by Ray Kurzweil's book *The Singularity Is Near: When Humans Transcend Biology*.

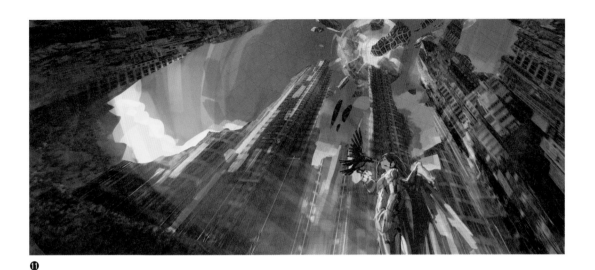

⓫

ストーリーが決まったので、ここから本格的に絵を仕上げていきます。全体に著作権フリーの写真素材を合成して下地にします。写真を合成することで情報量が増え、さらに仕上げまでの作業コストを大きく削減することができます⓫。

Now that I had the narrative in place, I started working seriously on the visuals. I first created a foundation by putting together various copyright-free photographic materials. Combining photographs increases the amount of information, and it also helps cut down costs involved in the creative process ⓫.

07 星を描き込む | Drawing a planet

→

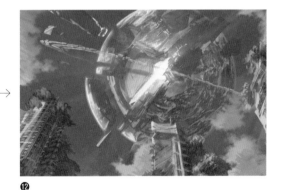

⓬

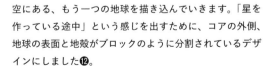

空にある、もう一つの地球を描き込んでいきます。「星を作っている途中」という感じを出すために、コアの外側、地球の表面と地殻がブロックのように分割されているデザインにしました⓬。

I drew another Earth up in the sky. In order to make it look like "a new planet being born," I chose to depict that Earth with its surface bursting into blocks as the crust breaks away from the core ⓬.

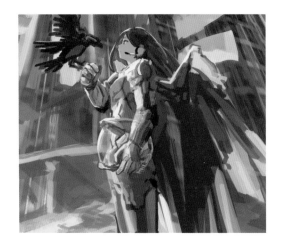

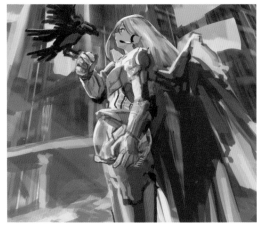

⓭

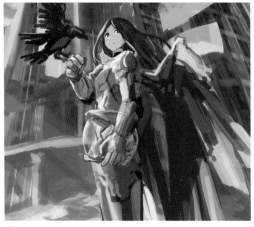

⓮

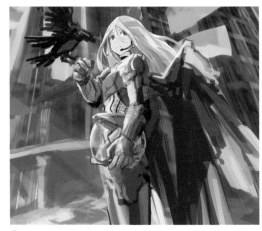

⓯

女性のデザインを試行錯誤して描きます。まず髪色が明るい方がいいのではと思い、⓭のように髪色だけを銀にしたパターン。

さらに、顔はこちらを向いている方がより魅力的になるのではと考え、⓮⓯のように顔の角度を変えたパターンを作りました。

このように思いついたアイデアは頭の中で完結させず、実際に描いて比較しながら判断することが大切です。

最終的に⓭の横顔と銀髪にすることにしました。

I tried out various things with the design of the character, beginning with the color of her hair. As it appeared to me that a light color would be preferable, I made a version with silver hair ⓭.

I also assumed that the character would be more appealing if she looked toward the viewer, so I created several different patterns with the face at different angles ⓮ ⓯.

As it is difficult to discuss these things based on logic alone, it is important to actually draw and compare different versions, and ultimately make your decision based on what you see.

The decision I arrived at was to draw the face in profile, and with silver hair ⓭.

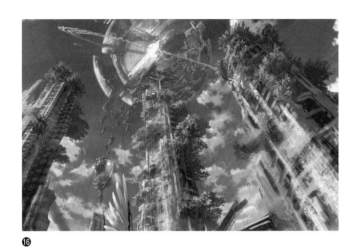

壮大さと自然の豊かさを表現するため、ビルから滝が流れていて、たくさんの植物と木の根に侵食されているようにしました。滝の水源は、ビルの頂上や側面にある大気中の水分を集めて放出するドローンです。AIは廃墟になったビルを中心に自然を復元しているのです❻。

⑯

In order to express the vastness and richness of nature, I drew the buildings overgrown and eroded with all sorts of plants and roots, and with waterfalls gushing out from their rooftops and sides, where drones function as water resources by collecting and releasing moisture captured from the atmosphere. It is mainly from such deserted buildings that AI works to restore the natural environment ⑯.

10 | キャラクターを仕上げる | Finalizing the main character

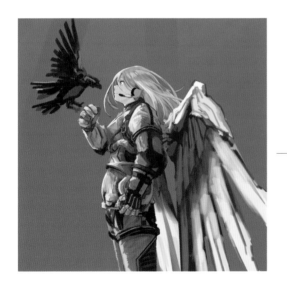

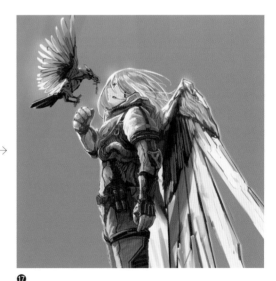

⑰

当初のパワードスーツのようなデザインではなく、もう少し現代の宇宙服に近いスーツに変更しました。最初は脇にヘルメットを抱えていましたが、お腹がぽっこりしているように見えるので、パーカーのフードのように収納されているデザインにしています⑰。

The design initially featured some kind of powered exoskeleton, but I eventually changed it to resemble a present-day space suit. I depicted the character with a helmet under her arm at first, but as it looked as if her belly was sticking out, I decided to incorporate the helmet into her armor like a foldable hood ⑰.

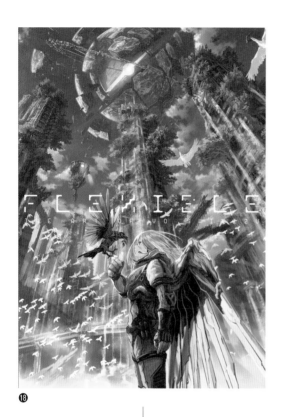

⓲

滝がたくさん配置されて水が豊富になったので、サギという水鳥を飛ばすことにしました⓲。

最初は鳥を多めに描きましたが、次の日に改めて絵を見ると、あまりにも白い鳥が多すぎてキャラクターやタイトルの印象を弱めてしまうことに気づきました。そこで一部の鳥を消して、あくまで絵を華やかにする程度のバランスになるように調整します⓳。

Having all the water in the background inspired me to add aquatic birds in the form of flying herons ⓲. I drew quite a lot of them at first, but when looking at the picture again later, I realized that all those white birds were somewhat mitigating the impact of the female character and the title. So I erased some of them until the balance seemed right, with the birds only being there to embellish the overall picture ⓳.

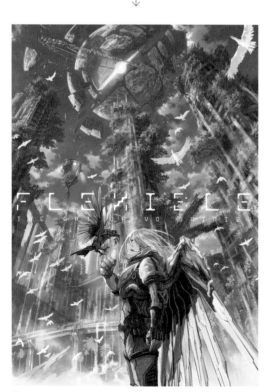

⓳

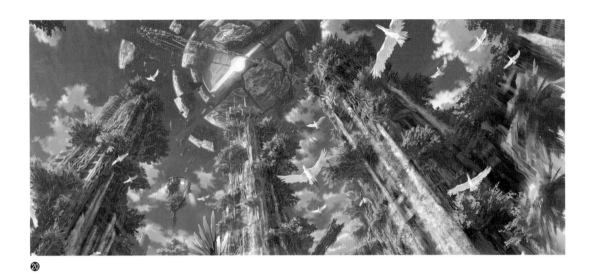

⑳

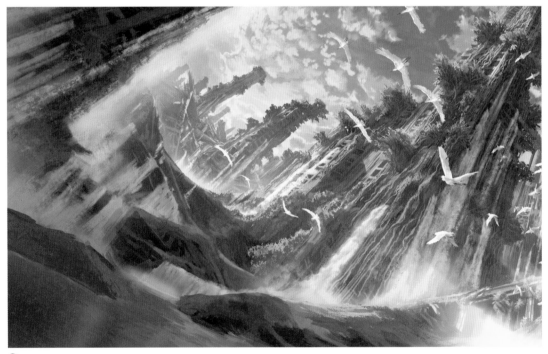

㉑

表紙部分が固まったので、左側の遠景にあるビルや丘、池などを描き込みます。空の色のグラデーションや光と影の部分を作って、ドラマチックさも加えました⑳ ㉑。

少し時間をおいて目をリセットしてから、改めて全体をブラッシュアップして完成です。

Once the cover part was done, I started drawing the pond with the buildings and hills in the background on the left-hand side. I added different shades of color and light, to make the sky look more dramatic ⑳ ㉑.

After putting it down for a while and resetting my creative eye, I returned to the picture one last time for a final brush-up.

おわりに

ここまで読んでいただき、ありがとうございます。

いろいろな作品を掲載しました。
かなり懐かしい作品もあって、「ああ、こんな絵も描いたなぁ」と懐かしく感じました。
絵を見ていると、大変だったことや嬉しかったことを思い出して、
まるでアルバムをめくっているような気持ちになりました。

本書は私の初めての商業画集になります。これまで技法書は何冊か執筆してきましたが、
画集というのはイラストレーターにとって一つの目標でもあり、また節目でもあります。

この画集を出版できたということを大変嬉しく思います。企画を持ちかけてくださり、
さまざまなサポートをいただいた編集の杵淵さん、デザイナーの杉山さん、
制作に関わってくださったパイ インターナショナルの方々、
そして本書を手に取りここまで読んでくださった皆様、本当にありがとうございます。

これからも「FLEXIBLE」な活動を続けていけたらと思います。

今後ともどうぞよろしくお願いします。

よー清水

Afterword

Thank you for reading thus far.

There are a variety of works featured in this book.
Some of them are a bit older, and looking at them again at this occasion brought back fond memories, feeling somewhat nostalgic as I recalled how I made them. I remembered how much trouble I had, but also how much fun I had making them, so browsing through these works was a bit like flipping through a photo album.

This is for me the first commercially published compilation of my work to date. I have published a few technical "how-to" books in the past, however for an illustrator, a book showcasing one's own creations is an important goal and a turning point at the same time.

I am extremely happy to be given the opportunity to publish this book.
My heartfelt thanks go to the editor, Ms. Kinefuchi, for approaching me with the plan for this book and offering broad support; to Mr. Sugiyama for designing the book; to everyone at PIE International for their engagement in the realization; and finally, to you, for picking up the book and reading these lines.

I am going to do my best to always remain "flexible" in my approach to creative work.

Yo Shimizu

初出・クレジット

P.014-015
『美しい情景イラストレーション ファンタジー編 幻想的な風景を描くクリエイターズファイル』装画
パイ インターナショナル（2017年）

P.022
『「ファンタジー背景」描き方教室　Photoshopで描く！心を揺さぶる風景の秘訣』装画
よー清水 著 / SBクリエイティブ（2016年）

P.024, 030, 032-033, 034, 035, 036-037, 066, 104-105, 106-107
『「ファンタジー背景」描き方教室　Photoshopで描く！心を揺さぶる風景の秘訣』作例イラスト
よー清水 著 / SBクリエイティブ（2016年）

P.028
『「キャラの背景」描き方教室　CLIP STUDIO PAINTで描く！キャラの想いを物語る風景の技術』装画
よー清水 著 / SBクリエイティブ（2018年）

P.029, 038-039, 052, 053
『「キャラの背景」描き方教室　CLIP STUDIO PAINTで描く！キャラの想いを物語る風景の技術』作例イラスト
よー清水 著 / SBクリエイティブ（2018年）

P.040-041
Adobe Photoshop CC 作例イラスト
アドビ株式会社（2017年）

P.042
『迷宮キングダム 特殊部隊SASのおっさんの異世界ダンジョンサバイバルマニュアル！』装画
原作：河嶋陶一朗／冒険企画局／ 著者：宮澤伊織／株式会社KADOKAWA（2019年）

P.043
『迷宮キングダム 特殊部隊SASのおっさんの異世界ダンジョンサバイバルマニュアル！』口絵
原作：河嶋陶一朗／冒険企画局／ 著者：宮澤伊織／株式会社KADOKAWA（2019年）

P.044
『百島王国物語 滅びの王と魔術歌使い』装画
佐藤二葉 著 / 星海社（2019年）

P.046-047（上）
『狼と香辛料ＶＲ２』キービジュアル
SpicyTails（2020年）

P.046-047（下）
『本好きの下剋上〜司書になるためには手段を選んでいられません〜』TVアニメEDカード #5
香月美夜 著 / TOブックス
©Miya Kazuki / TOBOOKS（2019年）

P.048-049
「味の素パーク」施策 Twitter投稿イラスト
味の素株式会社（2018年）

P.051（上）
『ポッキー公式twitter』2020年ポッキー＆プリッツの日企画 イラスト
よー清水 作（2020年）

P.051（下）
『ポッキー公式twitter』2018年ポッキー＆プリッツの日企画 #ポッキーミュージアム 2018 イラスト
よー清水 作（2018年）

P.054-055
『絵がふつうに上手くなる本 はじめの一歩×上手い絵の技術×安定して稼ぐ秘訣』装画
よー清水 著 / SBクリエイティブ（2021年）

P.056-057
『コミックマーケット97 紙袋大』イラスト
よー清水 / コミックマーケット準備会（2019年）

P.058-059
『お絵かき講座パルミー　5周年イラストコンテスト』メインビジュアル
株式会社パルミー（2019年）

P.061
『絵師100人展 11』
© 産経新聞社 / よー清水（2021年）

P.110-111
Adobe Stock 広告イラスト
アドビ株式会社（2017年）

P.112-113
『ATOUN Vision 2030』
プレス発表資料イメージイラスト
株式会社ATOUN（2020年）

P.114
『Identity V 第五人格』「お月見」イラスト
NetEase Games（2020年）

P.115
『Identity V 第五人格』「漢字の日」イラスト
NetEase Games（2020年）

P.116-117
『Death end re;Quest』コンセプトアート2
株式会社コンパイルハート（2017年）

P.118-119（上）
『Death end re;Quest』コンセプトアート1
株式会社コンパイルハート（2017年）

P.118-119（下）
『Death end re;Quest』コンセプトアート3
株式会社コンパイルハート（2017年）

P.120-121
『Death end re;Quest 2』コンセプトアート
株式会社コンパイルハート（2020年）

P.125
『神獄塔 メアリスケルターFinale』コンセプトアート
株式会社コンパイルハート（2020年）

P.126
『神獄塔 メアリスケルター2』コンセプトアート
株式会社コンパイルハート（2018年）

P.127
『神獄塔 メアリスケルター』コンセプトアート
株式会社コンパイルハート（2016年）

P.128-129
『アークオブアルケミスト』世界観イメージボード
株式会社コンパイルハート（2019年）

P.132-135
劇場中編アニメーション『甲鉄城のカバネリ 海門決戦』
コンセプトアート
© カバネリ製作委員会（2019年）

P.136-147
ゲーム『甲鉄城のカバネリ -乱-』コンセプトアート
© カバネリ製作委員会 / DMM GAMES /
TriFort,Inc. All Rights Reserved.（2018年）

P.148-157
オリジナルテレビアニメ
『Vivy -Fluorite Eye's Song-』イメージボード
©Vivy Score / アニプレックス・WIT STUDIO（2021年）

P.158-160
『終末のハーレム ファンタジア』デザイン協力
原作：LINK / 漫画：SAVAN 著 / 集英社（2020年）

よー清水 | Yo Shimizu

コンセプトアーティスト、デザイナー、イラストレーター。学生時代からフリーランスでゲーム、アニメを中心にコンセプトアーティストとして活躍。主な参加作品は『FINAL FANTASY VII REMAKE』（スクウェア・エニックス）、『GUNDAM FACTORY YOKOHAMA』（創通・サンライズ）、「ヒプノシスマイク」（キングレコード）、『甲鉄城のカバネリ 海門決戦』（WIT STUDIO）など。近年ではグッズイラストや広告、漫画、技法書、クリエイティブソフトの開発協力など、あらゆるメディアへ活動の場を広げている。

FLEXIBLE | よー清水作品集

2021年9月28日　初版第1刷発行

著者
よー清水

装丁・本文デザイン
杉山峻輔

翻訳
シュトゥールマン アンドレアス
株式会社 シュタール ジャパン

編集
杵淵恵子

発行人
三芳寛要

発行元
株式会社 パイ インターナショナル
〒170-0005　東京都豊島区南大塚 2-32-4
TEL 03-3944-3981　FAX 03-5395-4830
sales@pie.co.jp

印刷・製本
株式会社廣済堂